Copperplate Calligraphy Practice Book

Step-by-Step Exercises to **Master Letterforms, Strokes,** and **More Pointed Pen Techniques** for Polished Script

Christen Allocco Turney

ULYSSES PRESS

Published by:
Ulysses Press
PO Box 3440
Berkeley, CA 94703
www.ulyssespress.com

ISBN: 978-1-64604-503-7

Printed in China through Regent Publishing Ltd.
10 9 8 7 6 5 4 3 2 1

Acquisitions editor: Claire Sielaff
Managing editor: Claire Chun
Editor: Renee Rutledge
Proofreader: Barbara Schultz
Cover art: Christen Allocco Turney
Interior design: what!design @ whatweb.com
Layout: Winnie Liu

TABLE OF CONTENTS

INTRODUCTION

Growing up, I was always fond of lettering and arts and crafts. I had every art kit under the sun, including a broad edge calligraphy set that gathered dust in my closet. It wasn't until my mid-20s that I took a year to experiment with all types of art—painting, drawing, photography, cake decorating, hand-lettering, and finally, calligraphy. My mom, forever a nurturer of my creative spirit, bought me a calligraphy book that Christmas. I shuffled through old art supplies to find that decade-old calligraphy kit, hidden between frayed paintbrushes and broken oil pastels.

My first letters were humble and homely, but I was smitten. I immediately connected with the slow, methodical rhythm of dipping a pen in ink and creating marks on the page. From there, my exploration of creative expression took a turn toward the rich tradition of penmanship and the lettering arts. In a matter of months, a pointed pen nib and oblique penholder dropped in my hand, and I'd found Copperplate calligraphy. From there, I immersed myself in study, attended conferences, studied under master penmen and met those who were just as, if not more, passionate than I was. Years of study and infatuation with script have led me here—sitting humbly, writing this book with the hope that you too will nurture the curious artist inside and find the joy of writing through Copperplate calligraphy.

Copperplate calligraphy is a classic, timeless script with thick, luscious swells and soft, delicate hairlines. Written with an oblique or straight penholder and a steel nib, Copperplate is romantic and thoughtful, marked by even spacing and contrast of weight. By applying and releasing pressure to the nib, you will create the heavy shades and gentle hairlines that form letters.

As the companion book to *Copperplate Calligraphy from A to Z* by my dear friend Sarah Richardson, this book will equip you with the resources, practice sheets, and guidance you need to learn calligraphy.

This book is designed to walk you through the letters and practice prompts in baby steps, resulting in consistent progress over time. You won't just write the letters and practice the strokes—you will experience the script up close, learn to examine your own work, and train your eye to see letters with a fresh and informed perspective. By sticking with it week after week, page after page, the letterforms and strokes will become ingrained in your mind, in turn allowing your hand to execute the letters with ease.

You won't be an expert overnight, but by repeatedly showing up at your desk, you will see improvements that will keep you coming back for more. I challenge you to commit to studying this book, one page at a time, over at least eight weeks. By working through the practice pages, you will discover the scribe within and add your own bit of magic every time you put pen to paper.

I am honored you chose this book to aid in your calligraphy journey. Here's to you and the beautiful work that is bound to flow from your pen. Happy scribing!

SUPPLIES

You only need a few basic supplies to start writing in calligraphy. From the paper you letter on to the pen you dip in ink, different results come from different supplies. In this chapter, you will discover the tools you need and learn how to use them. Be warned, while you *technically* only need a few basic supplies, you will soon be tempted by the world of metallic inks, handmade paper, and hand-turned penholders.

Calligraphy Nibs

The magic of calligraphy lies in the use of a nib dipped in ink. A nib is a small piece of metal that, when dipped in ink, makes marks on the paper. In calligraphy, there are many types of nibs in all shapes, sizes, colors, and levels of flexibility. The most common nibs are broad edge nibs and pointed pen nibs. Broad edge nibs have a flat square top that creates very thick, uniform shapes. To write in Copperplate calligraphy, you will use a pointed pen nib fastened into a penholder. A pointed pen nib is triangular in shape and has two tines—pieces of metal that end in sharp points. When pressure is applied to the nib, the tines spread apart to release ink onto the paper and produce beautiful swelling lines. When the tines are closed,

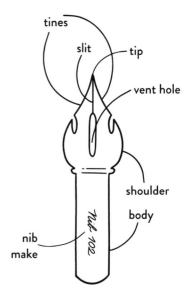

the nib creates graceful hairlines. This contrast of thick and thin strokes contributes to the signature style of Copperplate calligraphy.

You'll notice that there is a tiny hole near the middle of the pointed pen nib. Believe it or not, this hole, also known as a vent or reservoir, holds ink so you can write several strokes, letters, or words before dipping in ink again.

Nib Preparation

Before you put pen to paper, it is important that you prepare the nib for writing. Nibs are coated in a factory oil to prevent rusting prior to use, which preserves the life of the nib and comes in handy if you buy in bulk. However, the oil repels ink, making it difficult to write and keep ink on your pen. This can be very frustrating for new calligraphers who cannot figure out why their ink keeps dripping on the paper. There are a few ways to prepare a nib for writing—some of these methods may seem a little unconventional, but they do the trick!

Method 1: Liquid Gum Arabic

Often used in painting and calligraphy to thicken paint or inks, gum arabic is a sap-based medium that adds brilliance or glossiness and prevents smudging. It also helps remove the factory coating from a nib. Gum arabic comes in both powdered and liquid forms; for this purpose, use the liquid version. Simply dip your nib in liquid gum arabic and use a paper towel to rub the nib on both sides for about 10 seconds. Wipe away any excess gum arabic.

Method 2: Flame

Light a match and carefully run the nib through a flame a few times. Do not let the nib sit in the flame. This should only take a few seconds. Wipe the nib with a paper towel or soft cloth to remove any soot.

Method 3: Saliva (yes... saliva)

Gracefully spit (I can't believe I am writing the word "spit" in my book) on a paper towel or soft cloth. Rub the nib in saliva on both sides for 10 to 20 seconds. Wipe away any excess saliva. It really does the trick. Do not put the nib in your mouth.

Method 4: Potato

Carefully stick the nib in a potato. Let the nib sit for a few minutes. Remove the nib and rinse in water, then wipe dry. I like to keep a potato on my desk for what I call a "nib refresh." After writing for a while, you might find that the flow of ink has changed. Over time, ink can clog the tines and vent. Rinse your nib, poke the nib in the potato and leave it there for a few seconds, rinse, wipe clean, and dip in ink. You'll find that your nib feels as good as new!

When to Retire a Nib

When I first started learning calligraphy, I did not know that nibs were disposable. For the life of me, I could not understand why one day my nib worked fine and the next I couldn't get a single stroke down on the paper. Was it me? No, it was likely the nib had reached its breaking point. How will you know when it's time for your nib to hang up its hat? Examine the nib. Are the tines separated, bent, or crossed? Is debris stuck between the tines? How are your hairlines—are they thicker now than when you first prepped the nib? Does the nib scratch more on the paper? These are all signs that you should replace the nib. When shopping for nibs, buy at least three of each type. Sometimes, a nib straight from the box will have misaligned, bent, or gaping tines.

To help preserve the life of your nib, keep it clean. Every 15 minutes or so, rinse your nib in water and wipe it clean with a paper towel to prevent ink from building up on the metal. When you are finished writing for the day, rinse and wipe your nib and either remove it from your penholder or store your penholder in a safe place to prevent the nib from getting bent.

Choosing the Right Nib

There are many nibs to choose from. Below is a list of some of the favorites I use for various projects. As you progress in your calligraphy journey, I encourage you to buy a few different pointed pen nibs to see how you like them. Do you prefer writing with a stiff nib or one that provides a little more pliability? Some nibs work better on handmade paper while others glide elegantly across smooth paper. Do you like the look of a thicker hairline? There's a nib for that too.

Recommended Nibs

Hunt 101: This is my go-to nib. I have a lighter hand and prefer a flexible nib. The Hunt 101 will last for a while, and with a good amount of pressure, you can achieve a juicy (can we call calligraphy strokes juicy?) thick stroke that sings.

Nikko G: While I do not use this nib very often, it is a fantastic nib for beginners. It is durable and a bit stiff, which will help the novice scribe learn to control the pressure. A Nikko G can last for several months, while other nibs retire in days or weeks.

Leonardt EF Principal: If you want thin hairlines and like a bit of flex, this nib is for you. This nib will write beautifully, but for a short period of time. Depending on how much you write, the type of ink you use, and the surface of the paper, you may need to replace a Leonardt EF Principal more frequently than other nibs. While a Nikko G may last you a couple of months, the Leonardt EF Principal may last you only a few days. Regardless, the quality of letters is worth the short life span.

Leonardt #40: This nib works great on peculiar surfaces like wood, handmade paper, seashells, and more. The hairline is quite thick, which comes in handy for signs or projects that require enhanced legibility.

Penholders

There are two types of penholders—oblique penholders and straight penholders. An oblique penholder is used by the majority of Copperplate calligraphers and has a metal flange that juts out from the side to hold the nib in place. Some calligraphers use a straight penholder, which uses a circular ferrule inserted into the foot of the pen instead of a flange. Left-handed calligraphers often prefer a straight penholder. A straight penholder can be used to write Copperplate but is more commonly used for broad edged scripts and flourishing. While an oblique penholder can feel a bit awkward in the hand at first, the unique placement of the nib in the flange allows you to write at the desired letter slant of 55 degrees more easily (more on that later!). New calligraphers can start learning with an oblique pen right away.

Penholders vary in price from just a few dollars to hundreds of dollars. If you are just starting out, I recommend a wooden or soft plastic penholder in the $10 to $30 range. Oblique pens should have a metal flange. Steer clear of pens with a plastic flange as it will limit your ability to adjust the angle at which your nib touches the paper.

Using a Pen and Nib

To use an oblique penholder, take a freshly prepped pointed pen nib and insert it into the flange. The nib should fit tightly in the penholder so it does not slip when writing, but you should also be able to remove the nib easily by giving it a gentle wiggle back and forth. You can use round-nose pliers to tighten or loosen the flange. You may need to adjust the flange for different-sized nibs. When you

hold the pen above the paper, the nib should hover parallel to the surface. If it is angled at all, bend the flange so that the nib lies flat.

To use a straight penholder, simply insert a nib into the ferrule at the foot of the pen. Make sure the nib is well secured in the penholder, while also leaving a little bit of room between the nib's reservoir and the foot of the pen. Should you decide to take up a broad edge script, you can use this same straight penholder with a broad edge nib.

How to Hold a Pen

Now that your pen is ready for writing, it is important to hold it the right way. Most calligraphers use what is called a tripod grip, holding the pen between three fingers while resting the hand gently on its side. To practice the tripod grip, hold the pen between your forefinger and thumb, allowing the pen to rest on your middle finger. The staff of your pen will rest in the crook between your forefinger and thumb. As you grip the pen, turn the barrel of your penholder so that the top of the nib is face up, hovering parallel to the paper. Avoid holding the nib at an angle, as it will add unnecessary wear to the nib and you may have issues writing.

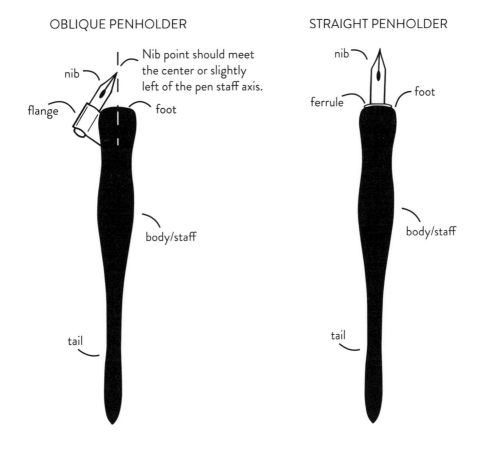

OBLIQUE PENHOLDER

nib

flange

Nib point should meet the center or slightly left of the pen staff axis.

foot

body/staff

tail

STRAIGHT PENHOLDER

nib

ferrule

foot

body/staff

tail

Ink

Walnut ink is made from walnut husks to produce a beautiful vintage brown color. Sumi ink is made from soot and leaves a deep opaque mark on the paper. These inks will write beautifully on many types of paper. You can use sumi ink at full strength or add a few drops of water to dilute it. The consistency of sumi ink should be that of heavy cream, whereas walnut ink will be looser and a little more transparent—the consistency of skim milk.

Beyond sumi and walnut, there are a plethora of inks you can try. Metallics, colored gouache, watercolor paints, iron galls, whites—the possibilities are endless.

To use your ink, insert the nib in your penholder. Pour the ink into a small wide-mouth jar or container. Dip the tip of the nib in the ink until the vent is submerged. After getting ink on the nib, I like to give my pen a little shake to drip off any excess ink. You will notice that your once-empty vent is now filled with ink. If the vent is still open, dip again. You will be able to write more strokes if the vent is full.

Try a test stroke: Put the tip of the pen to the paper. Slowly pull the nib toward your body, adding pressure to the nib so that the tines open to deposit ink on the paper. Lift up your pen. Now gently draw a stroke upward with no pressure to create a hairline. Congratulations, you just made your first calligraphy marks!

If you were unable to make marks on your paper, make sure your nib has been prepped. Check the consistency of your ink. Too loose and too thick can both be culprits!

Paper

Different ink and paper combinations may lend a variety of results. On certain papers, you may find that your ink bleeds (soaks through the paper onto the sheet below) or feathers (the ink expands or "feathers" out from where you originally placed the ink, causing your letters to look fuzzy). To mitigate these issues, you can spray your paper with hairspray for non-archival pieces or a fixative spray for archival pieces. Soak your paper with the spray and allow it to dry completely before writing. Make note of which side you sprayed. For practicing, you can use a 32 lb copy paper or a semitranslucent layout bond paper. For final pieces, hot press watercolor paper is smooth and nice to write on. If you're feeling fancy, you can purchase handmade cotton paper. You'll deal with nib snags and will need to write *very* slowly, but the result is simply stunning.

A CLOSE-UP OF COPPERPLATE

Calligraphy comes in many shapes, sizes, and forms. Copperplate has unique features compared to other styles of calligraphy. After reading this section, you'll know how to spot Copperplate in the wild and be aware of these subtleties as you write.

X-height: In all forms of calligraphy, the x-height is the height of a minuscule or lowercase letter (x, n, a, m, c, etc.) and is used as a measurement of spacing. In broad edge calligraphy, an x-height is determined in nib widths. For instance, if a broad edge nib is 2 mm wide, and the x-height for a particular script is 5 nib widths, the x-height should be 10 mm tall. In pointed pen calligraphy, the x-height is not related to the nib size. You can choose the x-height size you need for your project.

Depending on the nib you use, you will notice a variance in shade. For instance, a stiff nib at a larger x-height will have thinner shades than a flexible nib. You will notice that different nibs will produce different results at the same x-height.

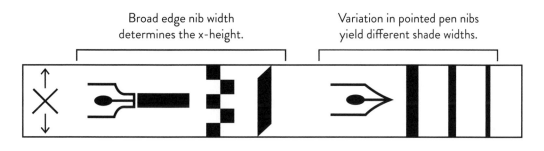

Broad edge nib width determines the x-height.

Variation in pointed pen nibs yield different shade widths.

Slant: Instead of writing upright like you would with print handwriting, Copperplate is written at a 55-degree slant. All Copperplate letters are sloped to the right. When writing, consistency is key. A letter off slant sticks out like a sore thumb.

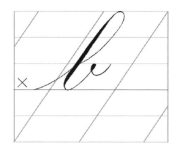

Ovals: The Copperplate alphabet is centered around the oval shape, which is integral in many letters and dictates spacing. For instance, you could fit an oval inside the counter (full or partially closed space of a letter) of the n, h, and v. The tops of loops of letters like h, l, and k mimic the top of an oval. Practicing ovals will help produce beautiful curves on your majuscule (uppercase) letters.

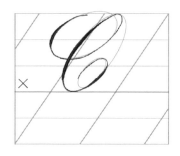

Shades and Hairlines: Copperplate letters are composed of hairline strokes and shaded strokes. As you move your pen, all upward strokes, or "upstrokes," are hairlines with no pressure while all downward strokes, or "downstrokes," are shaded with pressure. There are other pointed pen scripts like Spencerian or Italian Hand that have much less shading.

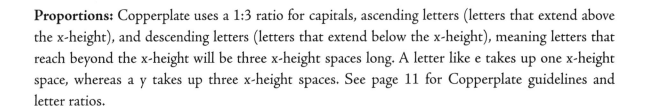

Hairlines on the upstrokes

Shades on the downstrokes

Proportions: Copperplate uses a 1:3 ratio for capitals, ascending letters (letters that extend above the x-height), and descending letters (letters that extend below the x-height), meaning letters that reach beyond the x-height will be three x-height spaces long. A letter like e takes up one x-height space, whereas a y takes up three x-height spaces. See page 11 for Copperplate guidelines and letter ratios.

Flourishing: Copperplate is a traditional script with few frills. It looks beautiful and timeless on its own. You can create a more stylized version of Copperplate by adding flourishes. Flourishes are decorative strokes that add whimsy and flair. Flourishing is a skill that you can add on once you learn the fundamentals of Copperplate.

Flourished Copperplate

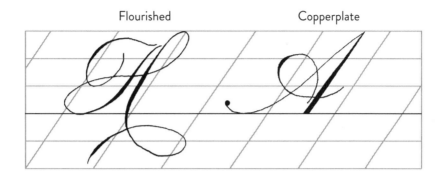

Copperplate Guidelines

Using guidelines will train you to stay on slant, write consistently, and maintain proper proportions. When setting up your page, draw six evenly spaced horizontal lines with 55-degree slant lines throughout. I have been writing for many years but still draw guidelines on my page for important projects.

As you study this book, pay close attention to where each letter is positioned on the guidelines. For instance, a letter t is two x-heights high, whereas a Z is five x-heights high.

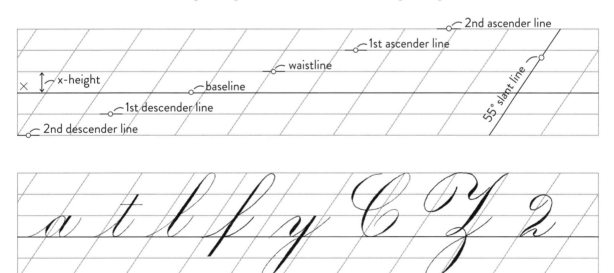

Guideline Terminology

Baseline: The baseline is the writing line upon which all letters sit.

Waistline: The waistline marks the height of letters that are confined to the x-height, like n, x, m, and o.

X-height: The space between the baseline and waistline.

Second ascender line: This line denotes the height of capital letters and ascending letters. Sometimes capital letters will stand just a hair below this line.

First ascender line: Instead of reaching the upper capital line, the letters d, t, and p are only two x-heights high and meet at the first ascender line. Numbers are also only two spaces high.

Second descender line: Most descending letters are three x-heights long and touch down at the second descender line. This includes letters like y, g, and z.

First descender line: Instead of reaching the lowest descending line, the letters f and p only reach the first ascender line.

Setting Up Your Page

Before you start writing, it's important to draw your guidelines and set up your page. Using a T-square or ruler, adjust your paper so that it is straight and in line with your measuring tool. Tape the paper in place using artist's tape or masking tape. Using a T-square, create evenly spaced guidelines including the baseline, waistline, ascender, and descender lines. Use whatever x-height you prefer. I recommend beginners start with a larger x-height, around a quarter inch, or 6 mm. Writing at a larger x-height allows you to better see what you're doing well and identify areas you can improve. Add 55-degree slant lines every one-half inch or so. Leave one to two x-heights of interlinear space between sets of guidelines.

Tip for easy slant lines: Using an 8.5 x 11-inch piece of paper, turn it so it is portrait (8.5 inches wide). At the top of the page, measure 7¾ inches wide. Draw a line from the bottom left corner of the page to the 7¾-inch mark at the top of the page. This will create a 55-degree slant. Using this drawn line as a guide, set your ruler along the slant and draw an additional line on the opposite side of the ruler. Continue across the page until you have enough slant lines.

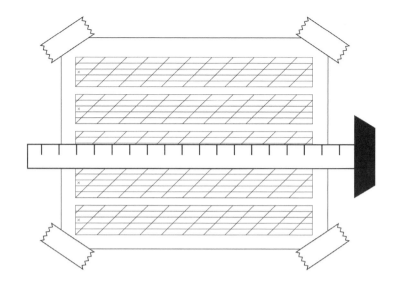

Now that your page is lined up, let's get ready to write! Sit so that your body is facing the desk head on with your feet flat on the ground. For right-handed calligraphers, turn your page counterclockwise until the slant lines are perpendicular to your body. Turning the page like this will make it much easier to align your letters with the slant and will allow the nib to apply even pressure. If you are left-handed, many calligraphers find it helpful to turn the page a full 90 degrees clockwise. Regardless of which hand you write with, always make sure the body of your nib is aligned with your slant line as you write. It is common for beginners to write with the nib pointed toward the top of the page. The nib should always point in line with the slant.

Before you put pen to paper, it is best practice to use a guard sheet. A guard sheet is a paper barrier that protects your writing page from the oils of your hand and any unwanted ink splatters or blobs. This is especially important for writing large pieces. If you do not use a guard sheet, you might find that your ink does not flow well on the paper as you get toward the middle of the page. Without a guard sheet, the natural oils from your skin will rub off on the page, preventing the ink from adhering to the paper. I like to use a piece of colored scrapbook paper as a guard sheet—it's more fun to use a guard sheet that has a pretty pattern or color.

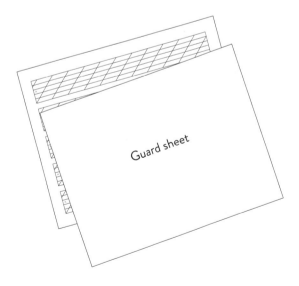

Guard sheet

A final step for preparing your work space is to add some padding beneath your writing page and guard sheet. You can use a newspaper section, a few extra pieces of paper, a sheet of felt, or, if you're feeling fancy—a leather blotter. This added padding creates a gentle, supple surface for writing. A hard surface will wear on your nib.

Tips for Lefties

For right-handed calligraphers, setup, pen hold, and paper orientation are pretty standard across the board. Lefties have a few more options to try. Stay optimistic and open to testing what will work best for you.

There are three pen holding options for lefties—a straight penholder, a right oblique penholder (the most common ones you will find), and a left oblique penholder. Most of my left-handed colleagues use either a straight penholder or a right oblique penholder. The key is adjusting your paper so the slant lines on your paper line up with the nib. Here are a few tips:

- **Using a straight penholder:** Turn your page about 30 degrees clockwise and align your pen and nib with the 55-degree slant. Try using a straight penholder first to see how it feels in your hand.

- **Using a right oblique penholder:** A right oblique penholder has a flange on the left side of the pen staff and is used by most right-handed calligraphers. As mentioned earlier in the book, you might find it helpful to turn your paper 90 degrees clockwise. Align your nib with the 55-degree slant. As you write, move your hand closer to your body. The method will help keep ink off your hands.

- **Using a left oblique penholder:** A left oblique penholder has a flange on the right side of the pen staff. Turn your page about 45 degrees counterclockwise and align your nib with the slant. This method may take time to get used to, as your nib may snag on the paper.

- **Using an exemplar reference:** As you study, turn your exemplar page to match the angle of your paper. If your page is turned a full 90 degrees clockwise, turn your exemplar to this same angle. Since you will not be writing straight, seeing the letters from the same vantage point will help you visualize the shapes of the letters in a new way.

Each calligrapher tends to have their own preferences, and it may take a little longer for you to determine what works best for you. There is no one "correct" way to write as a lefty. I encourage you to be patient with yourself through this process and consider taking time to try a few different options.

BASIC STROKES AND FORMING LETTERS

At first glance, calligraphy might look incredibly complex. When you break down each letter into basic strokes, calligraphy becomes much more achievable. All of calligraphy works this way, and Copperplate is no different—we'll take it stroke by stroke until we form letters, then words, then phrases.

The basic strokes are the building blocks of every letterform. Practicing these strokes first will yield solid letterforms and consistency in your work. In this section, you will learn the basic strokes for the minuscule (lowercase) and majuscule (uppercase) letters.

Minuscule Basic Strokes

Straight line: While a full straight line is very rarely used in Copperplate calligraphy, understanding how to achieve this shape will help with your other strokes. The goal of this shape is to achieve squared-off tops and bottoms, meaning that the top and bottom of the stroke are straight and sit along the waistline and baseline. Please note, this is an advanced move! Don't get discouraged if you have a hard time getting this shape down. Since we're beginners here, I want to show you the easiest way to get this stroke first.

Draw a small line along the waistline the width of a full-pressure stroke. Align the tines of your nib with this tiny stroke and pull a full-pressure stroke down along the slant line. As you approach the baseline, snap your right tine to the left corner of the stroke to square off the bottom, if you can.

Touch up any areas that are not in full shade. I'll tell you a secret: most calligraphers touch up their work! Don't be afraid to clean up a stroke by adding a little more shade or filling in a spot you missed; we all do it.

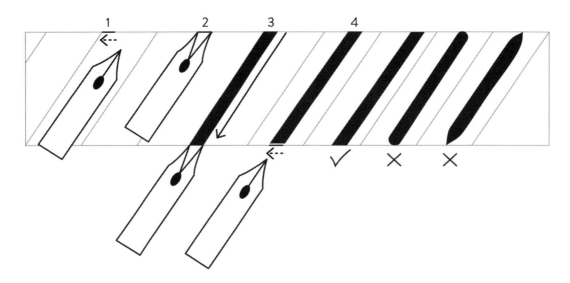

Pen manipulation involves twisting your pen with your fingers and applying focused pressure to create a special stroke. To create a squared off top using pen manipulation, start in the top right-hand corner of where your stroke will be. With the right tine anchored, move the left tine along the top of the waistline to create a tiny horizontal stroke, then begin to pull a full-pressured stroke that aligns with the slant. As you approach the baseline, snap your right tine to the left corner of the stroke to square off the bottom.

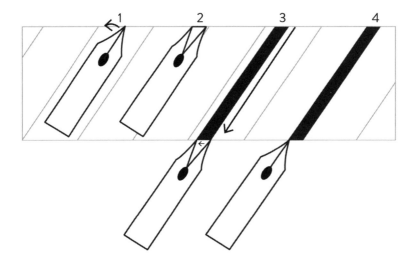

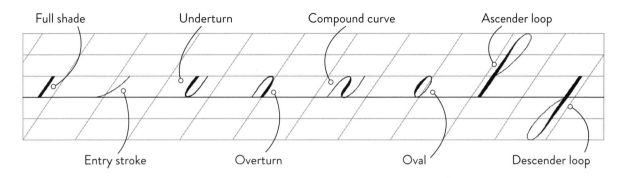

Full shade · Underturn · Compound curve · Ascender loop

Entry stroke · Overturn · Oval · Descender loop

Entry stroke: An entry stroke starts every word and letter. The entry stroke starts at the baseline and moves upward almost 45 degrees, with a bend in the middle. Depending on the letter that follows, the stroke will end about two-thirds to three-quarters of the way up to the waistline. The entry stroke should look like it naturally stems from the main portion of the letter; it should not jut out from the side a letter. It's a graceful hairline curve.

Underturn: An underturn starts at the top of the waistline with a sharp, squared-off top. Use full pressure to drag the stroke along the slant toward the baseline. As you approach the bottom quarter of the x-height, slowly release the pressure and begin to turn to the right to form a u shape along the baseline. Without lifting your pen up, continue upward and draw a hairline parallel to the shade to reach the waistline.

Overturn: An overturn is an upside-down underturn. Starting at the baseline, draw a hairline stroke up toward the waistline. As you approach the top quarter of the x-height, move toward the right to create an upside-down u shape along the waistline. Just a smidge below the waistline, begin to apply pressure and drag a full-pressure stroke along the slant down toward the baseline. At the baseline, square off your stroke.

Compound curve: Let's put the overturn and underturn together. Start at the baseline, draw a hairline stroke up toward the waistline. As you approach the top quarter of the x-height, move toward the right to create an upside-down u shape along the waistline. Just a smidge below the waistline, begin to apply pressure and drag a full-pressure stroke along the slant down toward the baseline. Instead of ending in a full-pressure, squared off stroke, release pressure near the bottom quarter of the x-height and turn to the right to form a u shape along the baseline. Without lifting your pen up, continue upward and draw a hairline parallel to the shade to reach the waistline.

Oval: An oval shape has a shade on the left side of the letter. The bulk of the shade is in the lower two-thirds of the shape. There are two ways to draw an oval. Imagine that the oval takes on the shape of a clock. Start at the 1 o'clock position and move your pen up to the waistline and to the left

to form a hairline upside-down u shape. About one-third of the x-height below the waistline, add a curved, pressurized stroke. As you near the baseline, release pressure and create a u shape moving to the right. Continue to close the oval in a hairline stroke until you meet your starting point. The whole oval should be slanted at 55 degrees.

As a second option, I like to start about one-third of the way down from the waistline, add the pressurized stroke, release near the baseline, and bring a hairline up and over to the left to close the shape. See which method works best for you. The second method ensures that the shade is placed in the bottom two-thirds of the shape.

Ascender loop: An ascender loop is graceful and about the width of an oval. There are two ways to create this stroke. Start at the waistline, draw a hairline stroke in an arched motion up toward the second ascender line. As you approach the top line, start to curve to the left, matching the shape of an oval to create an upside-down u shape. About halfway between the first ascender and second ascender lines, add pressure and gradually create a full-pressure stroke along the slant that ends in a squared-off bottom at the baseline. One thing to note, the arched shape of the loop is not symmetrical, the top of the loop should be more billowed than the bottom of the loop.

Another way to create this shape is to start with the pressured stroke. About halfway between the two ascender lines, add pressure and form a full pressured stroke along the slant that ends in a squared-off bottom at the baseline. Go back up to the point you started at. In hairline, draw an upside-down u shape that hits the second ascender line, then start to arch inwards to meet the shaded stroke at the waistline. If you find that your ascender strokes have too much weight at the top of the letter, this stroke sequence, or ductus, will help prevent unwanted shade in the upper ascender space.

Descender loop: The descender loop is an upside-down ascender loop. Start at the waistline with a squared off top, pull using full pressure toward the second descender line. About halfway between the first descender and second descender lines, release pressure and create a hairline u shape that sits on the second descender line. Move up and to the right in an arched hairline shape to meet the pressurized stroke at the baseline.

Majuscule Basic Strokes

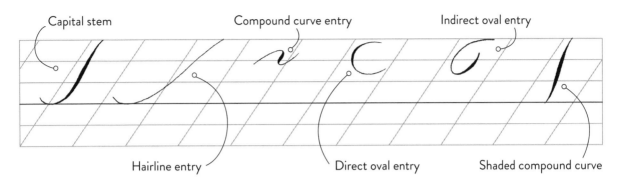

Capital stem · Compound curve entry · Indirect oval entry · Hairline entry · Direct oval entry · Shaded compound curve

Capital stem: This stroke, also known as the universal line of beauty, is at the core of many majuscule letters. This is a curved stroke that follows the slant line. Make sure it does not become too rigid. Start just below the second ascender line with no pressure, move slightly down and to the left, add pressure above the first ascender line, and release near the baseline. Continue to come up and to the left in hairline. As you study the letters, you will notice that most capital strokes end with a teardrop-shaped shade.

Hairline entry: This entry is an expanded capital stem without shade. There are two ways to achieve this shape. Start at the second ascender line as we did for the capital stem, and move down and to the left with zero pressure. As you approach the baseline, turn up and end about one-third of the way above the baseline.

The second way to draw this stroke is to start one-third of an x-height above the baseline. In all hairline, dip down to the baseline to create a u shape, then continue gracefully up toward the second ascender line. There should be a very subtle overturn curve near the top of the stroke.

Compound curve entry: This entry stroke is very similar to the minuscule compound curve. You can stretch the entry and exit points a little bit to create an open entry stroke that hovers near the first ascender line. Start in hairline a little below the first ascender line. Come up and over to the right, add a shade in line with the slant, release pressure a little below the first ascender line. Come back up in hairline. The hairline exit stroke will appear as though it stems from the main strokes of the letter.

Direct oval entry: A normal or "direct" oval is drawn in a counterclockwise direction. Start near the second ascender line in hairline, then move to the left in an oval motion. Gradually add pressure, then release a little above the waistline, curving up slightly to the right. This oval shape is at a more severe angle than a normal oval. The shade is still on slant, but the shape is more open.

Indirect/reverse oval entry: An "indirect" or "reverse" oval moves in a clockwise direction. Start about halfway between the two ascender lines in hairline. Quickly add shade, creating an oval to the left. Release pressure a little bit above the waistline. Continue up and over to the right in hairline.

Shaded compound curve: The shaded compound curve will sometimes deviate from our slant line rule. This stroke is not quite upright, but not always aligned with the slant. When paired with other strokes, the full letter will appear to be on slant, trust me. Start at the second ascender line in hairline and create a subtle compound curve, gradually adding pressure and releasing before you hit the baseline.

Turn Strokes into Letters and Words

Draw one stroke at a time, picking the pen up off the paper between each stroke. If you ever learned cursive, you might remember that most words are written in a fluid, continuous motion. When I write Copperplate calligraphy, I pick up my pen *all* the time. Sometimes I will even break up a stroke into two. For instance, instead of creating an underturn in one stroke, I will pick up at the baseline and resume the motion again before finishing the stroke. Pausing helps to be intentional about each stroke. It's also worth noting that Copperplate is a slow script. For reference, it takes me about seven to eight minutes to address an envelope. It takes time, but the result of thoughtful, precise script is worth it.

Let's Put a Letter a Together

Draw an entry stroke, ending about two-thirds of the way above the baseline. Create an oval shape that touches the entry stroke. Notice how the entry stroke branches seamlessly from the oval shape. Now add an underturn that just barely kisses the oval shape. We have an a!

Connecting Letters

When stringing letters together, the last stroke of your letter, also known as an exit stroke, becomes the entry stroke that leads into the next letter. All letters are connected by entry and exit strokes.

For example, as you write the letter a and exit in an underturn stroke, instead of ending near the baseline, curve to form an overturn. Add a compound curve and end the stroke near the waistline. We now have the word "an." Notice how the exit stroke of the a curves and gracefully turns into the entry stroke of the n.

Construction of a	Construction of n	Connection from underturn to overturn
a ou	*n n v*	*an*

Letter Spacing

Remember that oval shape we talked about? Use the width and general shape of an oval to help you with spacing your letters. Overturns, underturns, and loops should all be the approximate width of an oval. You can also use an oval as a guide for spacing between letters.

Tip: Write a few words. Place a piece of tracing paper over your writing and draw oval shapes over and between letters to find areas you can improve. This exercise will help you to see where you can tighten or open spacing between letters.

spacing spacing

Word Spacing

A good rule of thumb is to place an imaginary letter n in between your words. It's just the right amount of space to give your words room to breathe without feeling isolated from the rest of the phrase.

Copperplate Calligraphy

Paragraph Spacing

When writing blocks of text, allow enough room for your ascending and descending letters to breathe. Depending on your project, you might want more or less interlinear space. Below are a few examples of good spacing and bad spacing. I recommend you leave one to two x-heights of space in between lines. If you are adding flourishes, you could add more space between lines to compensate for the added details.

Good spacing Flourishing spacing Poor spacing

Preparing for Writing

Prep Your Space

It's almost time to write! Draw your guidelines on your paper and grab your guard sheet, nibs, penholder, and ink. Have a cup of rinse water nearby and set your ink on the side closest to your writing hand. Set a few paper towels under your ink pot to catch any ink splatters as you shake off excess ink. Now you're ready to warm up.

Warm-Ups

Just as an athlete stretches or jogs before a workout or game, a calligraphy warm-up will help get your finger, hand, and arm muscles ready for a writing session. Take 5 to 10 minutes to complete the exercises below every time you write. Warming up will help create clean, smooth curves and give you a feel for the pressure you will apply as you write. When I don't warm up, I inevitably produce

shaky letters and sloppy shades during the first few words and phrases. Warm-ups will give you more control and consistent results when you start to write. You may warm up with a pencil or a pointed pen nib.

Oval warm-up: With the writing tool of your choice, use your whole arm to create a quick, continuous stream of ovals with a very light touch. Do not apply pressure. Your fingers should not move—they should grip the pen, but your upper arm should do the moving. This is called whole-arm movement. Check the back of your paper—if you can see indents from the pen or pencil, you are applying too much pressure.

Figure eights: Use whole-arm movement to create figure eight shapes across the paper. Like the ovals, these should be light and quick.

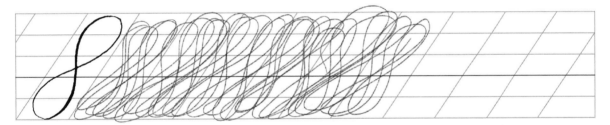

Infinity loops: Similar to what you did when creating the figure eights, use whole-arm movement to create horizontal infinity loops. Try changing direction as you create columns of these shapes.

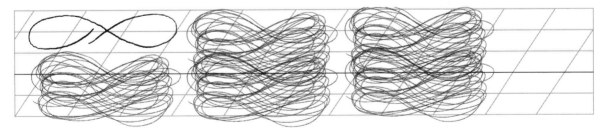

Shaded ovals: If you are using a pencil, switch to a pointed pen. Practice making shaded ovals. These do not need to be perfect; remember, you are just warming up. Try making ovals in both clockwise and counterclockwise motions.

Shaded spirals: With a pointed pen nib, practice making tight oval-shaped spirals. Add pressure on your downstrokes. You can try starting with whole-arm movement and gradually switch to using your fingers to make the strokes as your shape gets smaller and smaller.

How It Started, How It's Going

Before you study this book, tear out the next page and write a phrase or name on the top half of the worksheet. Save it as a reminder of when you started your calligraphy journey. When you complete the book, come back and write the same phrase on the bottom section. I just know that with productive, persistent practice comes results. I can't wait to see how far you come as you make time to study and finesse your letters.

How It Started

How It's Going

Date

ALPHABET EXEMPLARS

In this section, you'll see examples of what your letters should and shouldn't look like. Tear out the exemplar and keep it by your desk for reference as you write. Study the pages with errors so you can be mindful of any issues as you write.

Majuscule Alphabet

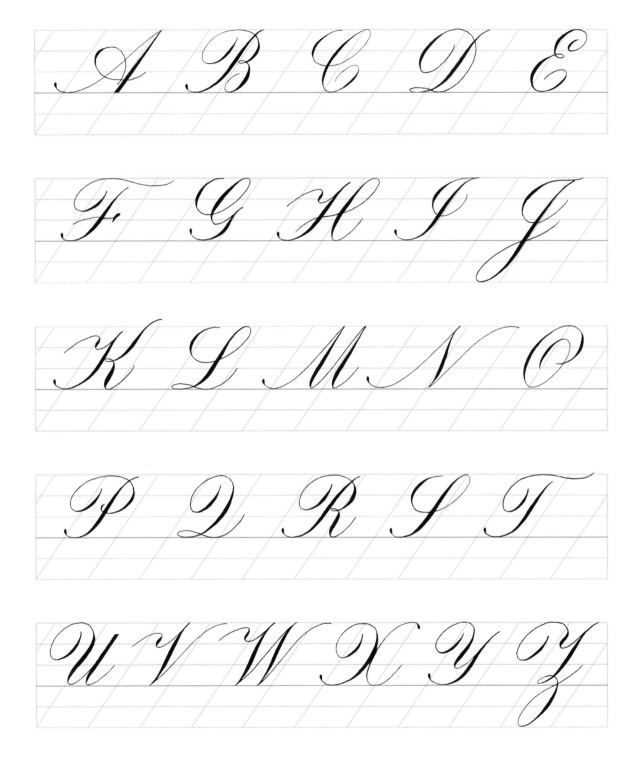

Minuscule Alphabet

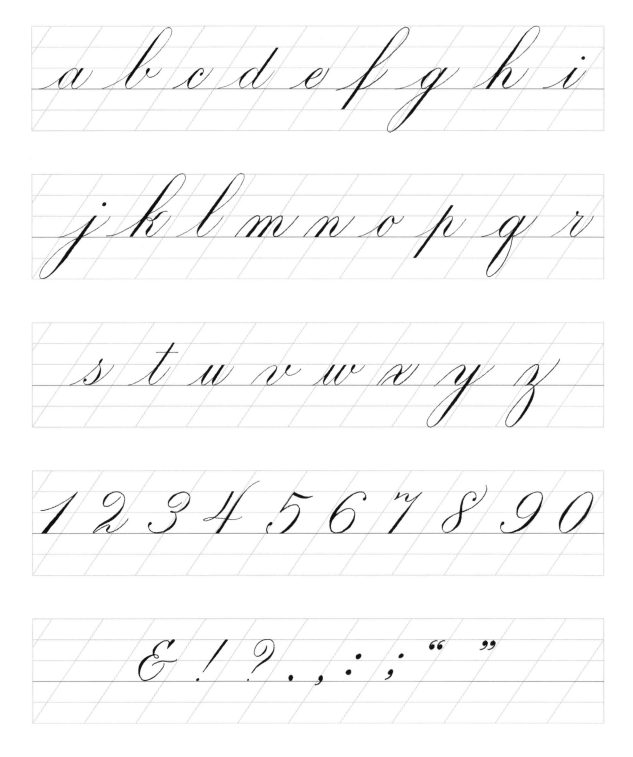

Loop too thin

Underturn is too
close to oval

Exit stroke
too tight

Stem too tall

Shape too
round

a a b b c c d e e f f

Underturn dips
below baseline

Small shade is in
wrong spot

Too round and
too open

Second shade
too thick

Loop too thin

Stem too
long

Loop too thin

Loop too big

Underturn is
not on slant

Loop too big

Dot too thin

g g h h i i j j k

Compound
curve too wide

Angle
too sharp

Dot too high,
shade not
squared off

Small loop
is filled

Loop too big

No squared
off shade

Too upright
and curved

Overturns
inconsistent

Compound curve
branches too low

Oval too round

k l l m m n n o o

Too wide

Loop too thin

Overturn angles
too sharp

Compound curve too
curvy/off slant

Second shade too
big, exits low

Stem too long

Loop too short

Loop should be
closed

Main curve
too wide

Exit too wide

p p q r r s s t u

Compound curve
branches too high

Loop should be
closed, stem
too short

Need two distinct
shades, not one

Stem too tall

Entry stroke
too low, shades
too wedged

Underturn
too wide

Second shade in
wrong spot

Compound curve
too stretched

Loop too thin,
compound curve
a bit wide

Overturn not
curved inward,
loop too thin

Loops too
wide

u u v v w x x y y z z

Entry too tight,
sloppy compound curve

Last shade too big,
exits low

Cross bar too
shaded

Loop too
small

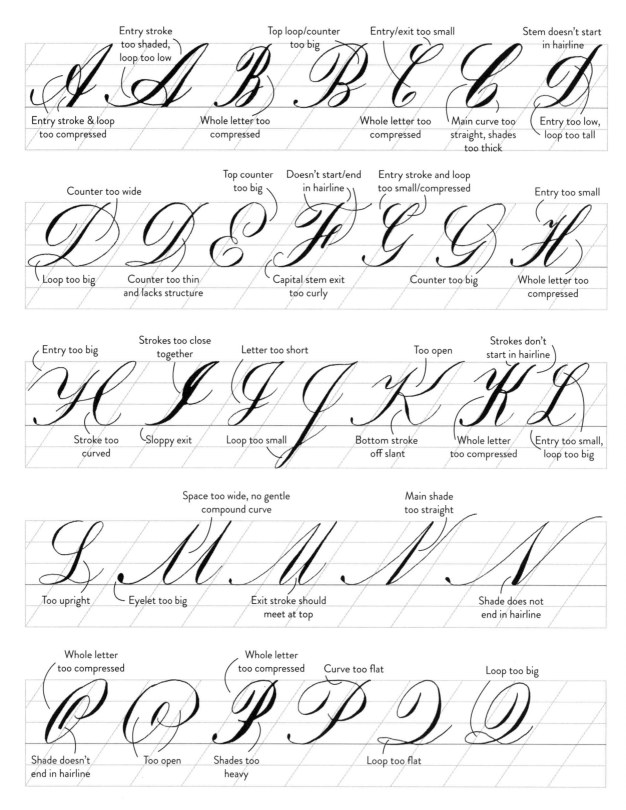

Entry stroke too shaded, loop too low

Top loop/counter too big

Entry/exit too small

Stem doesn't start in hairline

Entry stroke & loop too compressed

Whole letter too compressed

Whole letter too compressed

Main curve too straight, shades too thick

Entry too low, loop too tall

Counter too wide

Top counter too big

Doesn't start/end in hairline

Entry stroke and loop too small/compressed

Entry too small

Loop too big

Counter too thin and lacks structure

Capital stem exit too curly

Counter too big

Whole letter too compressed

Entry too big

Strokes too close together

Letter too short

Too open

Strokes don't start in hairline

Stroke too curved

Sloppy exit

Loop too small

Bottom stroke off slant

Whole letter too compressed

Entry too small, loop too big

Space too wide, no gentle compound curve

Main shade too straight

Too upright

Eyelet too big

Exit stroke should meet at top

Shade does not end in hairline

Whole letter too compressed

Whole letter too compressed

Curve too flat

Loop too big

Shade doesn't end in hairline

Too open

Shades too heavy

Loop too flat

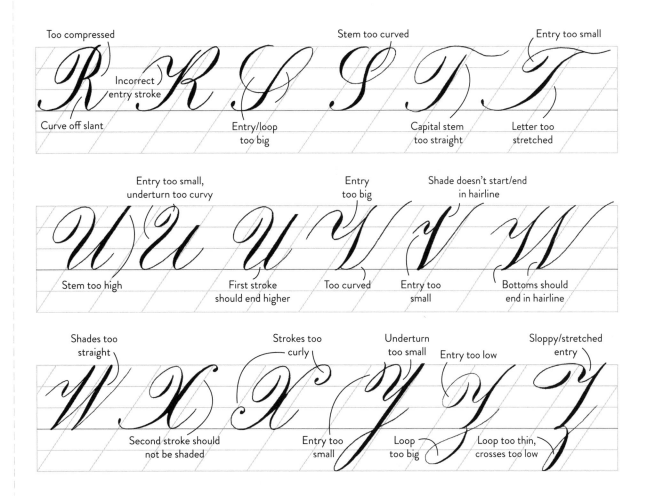

Too compressed

Incorrect entry stroke

Curve off slant

Stem too curved

Entry too small

Entry/loop too big

Capital stem too straight

Letter too stretched

Entry too small, underturn too curvy

Entry too big

Shade doesn't start/end in hairline

Stem too high

First stroke should end higher

Too curved

Entry too small

Bottoms should end in hairline

Shades too straight

Strokes too curly

Underturn too small

Entry too low

Sloppy/stretched entry

Second stroke should not be shaded

Entry too small

Loop too big

Loop too thin, crosses too low

CONCLUSION

Tips for Practice and Study

As you dive into this book, you'll find plenty of practice pages to guide you as you learn the letters. Now that you've learned the basics, it's time to put it all into practice.

A few tips:

- **Schedule practice time:** The best way to advance in Copperplate is to commit to practice. Set aside 30 to 60 minutes a few times a week to practice. The more you practice, the more comfortable you will become.

- **Flip your paper:** After you write a line or two, flip your page upside down and look at your writing from a different point of view. Right away, you'll notice whether your letters are off slant or if you need to apply more pressure to certain strokes.

- **Work through this book little by little:** The practice pages are grouped based on the shapes of the letters, which will allow you to work on one technical skill at a time. Take time to study each page and each group before moving on to the next section.

- **Check your spacing:** Place a piece of tracing paper over the top of your writing. Draw ovals over the letters and spaces between letters and words to see if your spacing is consistent.

- **Check your entry strokes:** Place a piece of paper over the top of your letters, revealing about one-third of the x-height above the baseline. How does your spacing look? Do your entry strokes look consistent?

- **Work on a project you are passionate about:** Look forward to your practice by making cards for friends or scribing your favorite quote.

- **Keep this book handy:** Even after you complete the practice pages, keep this book by your side as you work on projects or even client work. Tear out the example page and keep it posted by your desk as a reference while you work. Continual study and reflection of your work will help you advance.

- **Move your paper:** As you write across your page, move the paper so that you can write comfortably. You do not need to stretch your arm to reach the far right of the page, or crunch your arm toward your body to squeeze letters in at the bottom. Shift your paper up or to the left to write with proper form. Most people have a 4- to 5-inch "writing zone" where they write comfortably, then move their paper.

- **Tear out the practice sheets before writing:** It will be easier to write with proper form on the practice sheets and achieve the 55-degree slant. Tear out the page and place it on your padded surface. Don't forget the guard sheet! You can use a binder clip to keep all your pages with the book.

Learning is a continuous journey. I have been studying Copperplate calligraphy for many years, but I still learn new things about the script. Something you learn today might truly click a few months or even years later. It's all part of the journey. Be patient with yourself and keep coming back to your desk.

MINUSCULE BASIC STROKES

These basic strokes are the building blocks for the Copperplate alphabet. It might seem tedious at times to practice strokes without writing letters or words. However, a good foundation and proper study of these forms will help you in the long run. Take time to analyze each stroke. Notice how the tops and bottoms of underturns and overturns mimic the top or bottom of an oval—gently curved—no sharp edges here! Pay attention to the placement of the shade in a compound curve; it tapers at the top and bottom and does not drag to the baseline. The oval is about half an x-height wide. When in doubt, flip your paper upside down and notice how the similar shapes look.

Straight line

Entry stroke

Underturn

Overturn

Compound curve

Oval

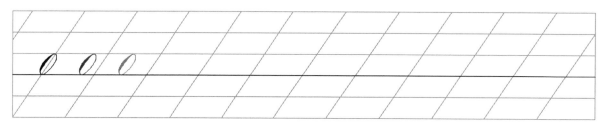

Ascending loop

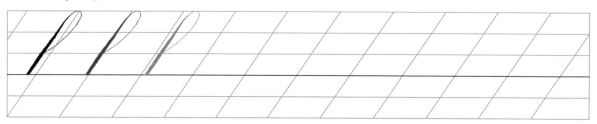

Descending loop

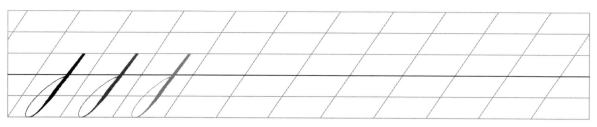

MINUSCULE GROUP 1: OVERTURNS AND UNDERTURNS

The letters in this group use two basic strokes: overturns and underturns. An i, for instance, is simply an entry stroke and an underturn with a dot over top. As you begin to combine strokes, aim for consistency in shade and spacing. Apply the same amount of pressure to your downstrokes each time. The repeated shapes, like the triple overturns in an m, should be the same width and carry the same weight.

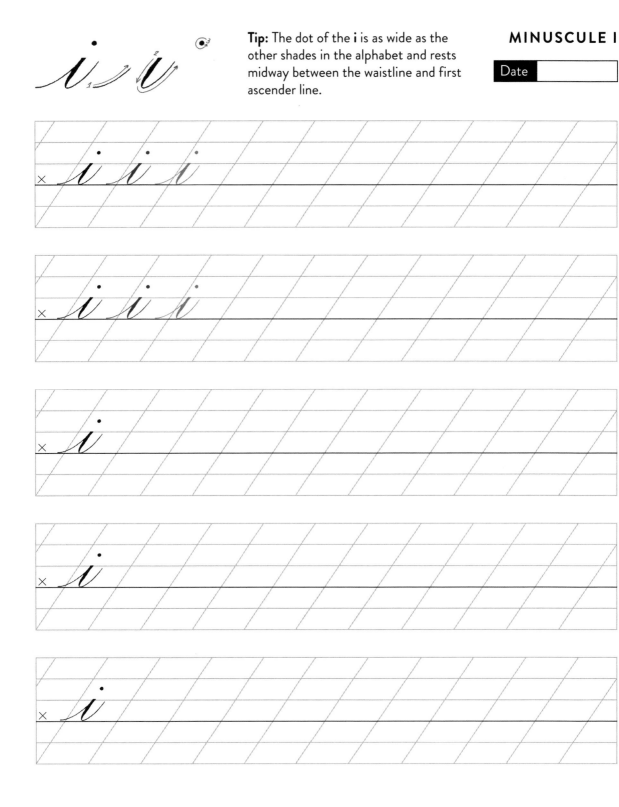

Tip: The dot of the **i** is as wide as the other shades in the alphabet and rests midway between the waistline and first ascender line.

Tip: The **t** is an underturn that starts at the first ascender line. Cross the t midway between the waistline and first ascender line. The cross bar should be about as wide as two ovals.

MINUSCULE T

Date

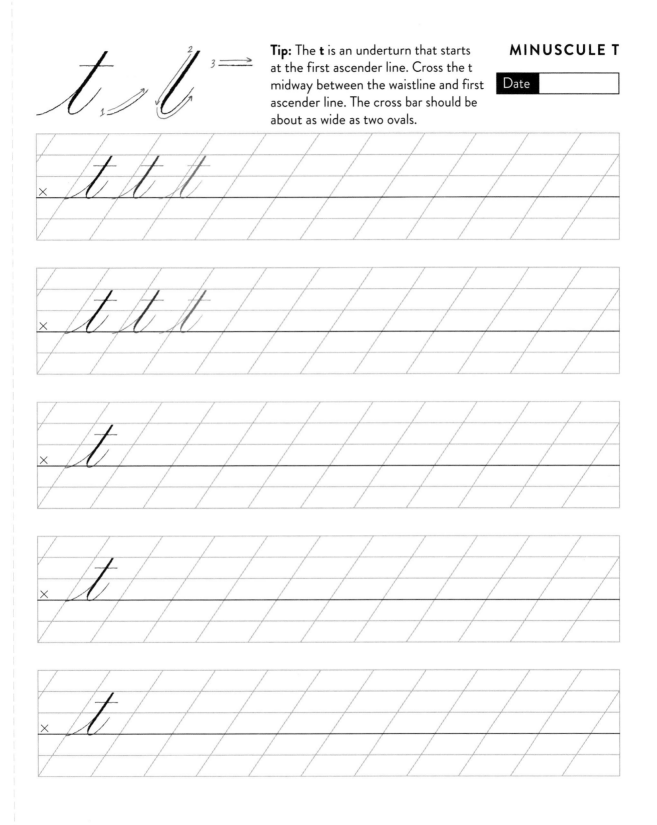

Tip: The **u** is two underturns side by side. Keep them uniform.

MINUSCULE U

Date

COPPERPLATE CALLIGRAPHY PRACTICE BOOK

Tip: Consistency is key! The spacing of the overturns and compound curve of the **m** should all be identical.

Date

Tip: Like the m, the spacing of the overturn and compound curve of the **n** should be identical in width.

MINUSCULE N

Date

COPPERPLATE CALLIGRAPHY PRACTICE BOOK

MINUSCULE GROUP 2: OVALS

The letters in this group revolve around the oval shape. Some letters like the o and a include full ovals, while letters like c and e end in an upstroke. The biggest piece of advice I can give you is to complete the oval shape in letters with stems. When writing the a and d, it can be tempting to start an oval and move to the right like a c, stopping short of completing the full oval. When paired with a straighter stroke, like the ascender of the d, the oval shape looks sharp as if jutting out from the stem. Instead, draw the full oval, then pull a shaded stroke that just barely touches the oval. The result is a graceful letter with proper spacing.

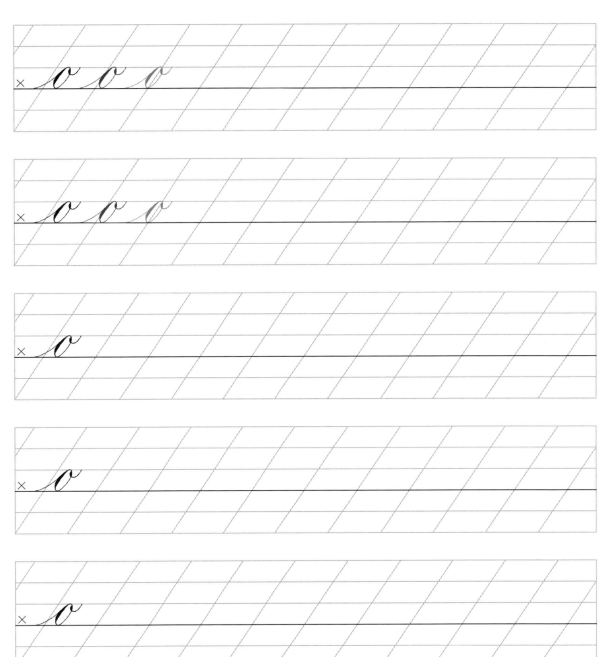

Tip: The eyelet is in the top right quadrant of the **o**. It loops out into a small underturn. The underturn is half an x-height high and about as wide as an oval.

Date

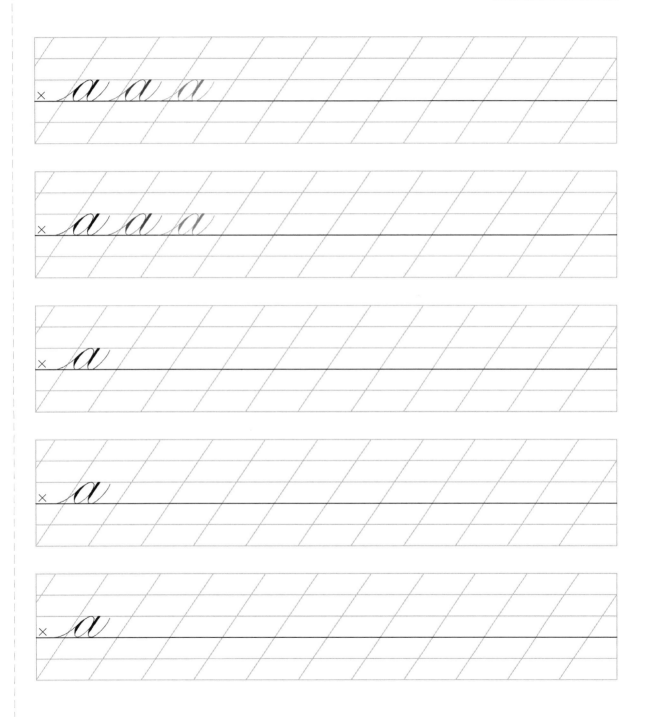

Tip: Make sure the counter of the **a** is a true oval shape that just barely kisses the underturn.

MINUSCULE A

Date

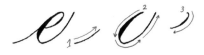

Tip: The **e** is an incomplete oval shape, with a small loop in the upper third of the x-height.

Date

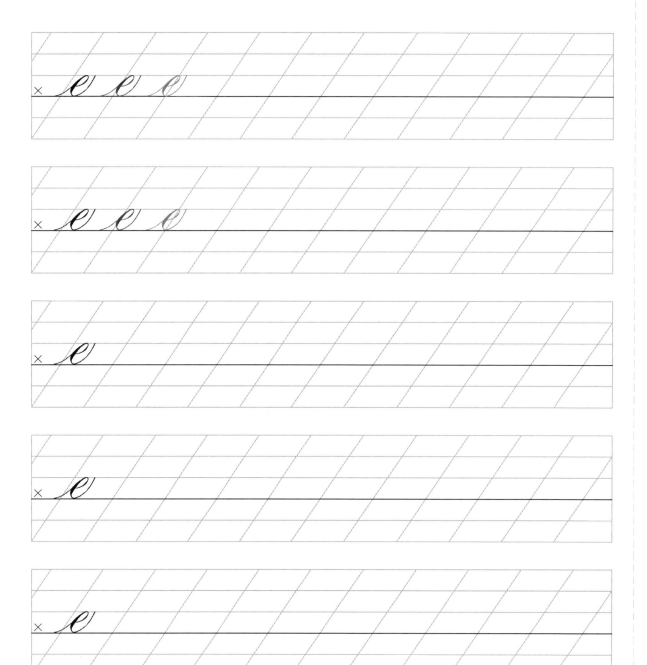

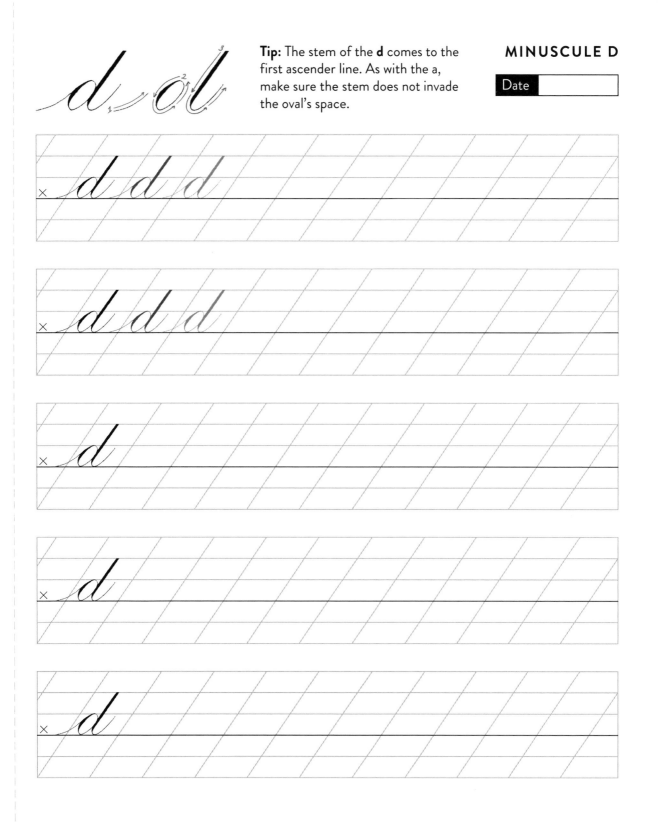

Tip: The stem of the **d** comes to the first ascender line. As with the a, make sure the stem does not invade the oval's space.

Date

Tip: The **c** is an incomplete is oval shape. Add the eyelet as a separate stroke, placing it approximately two-thirds above the waistline.

Date

MINUSCULE GROUP 3: ASCENDERS

Ascenders were always the hardest letters for me to learn. Those ascending loops can take time to perfect, but I have a few tips for learning this shape. Remember, the loop is not actually symmetrical. The widest part of the loop is in the top ascender space. The top curve of the loop should mimic the top of an oval.

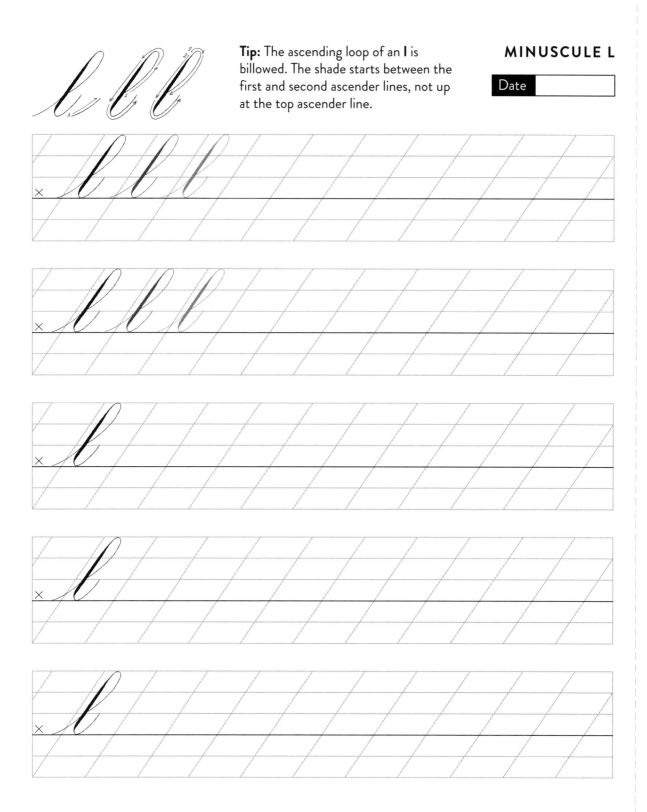

Tip: The ascending loop of an **l** is billowed. The shade starts between the first and second ascender lines, not up at the top ascender line.

Date

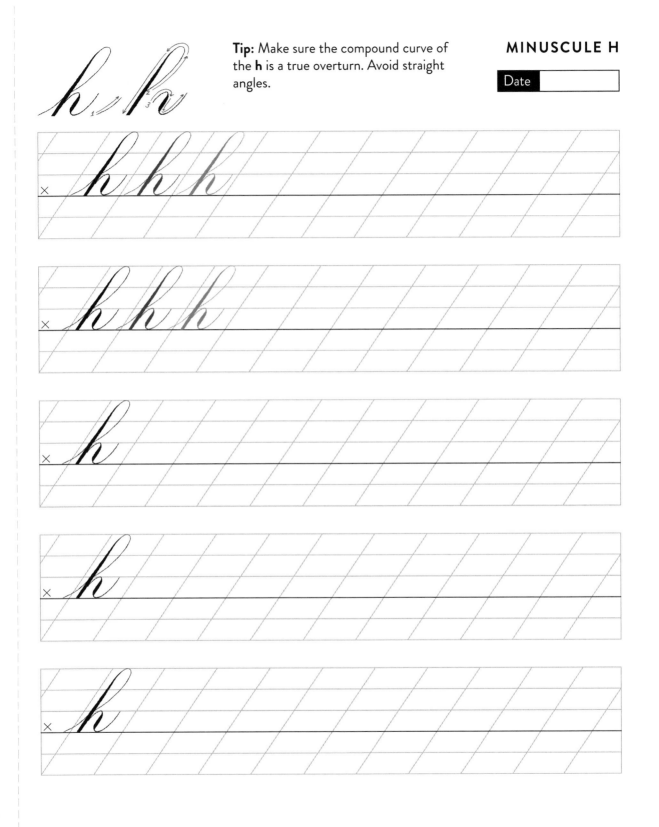

Tip: Make sure the compound curve of the **h** is a true overturn. Avoid straight angles.

Date

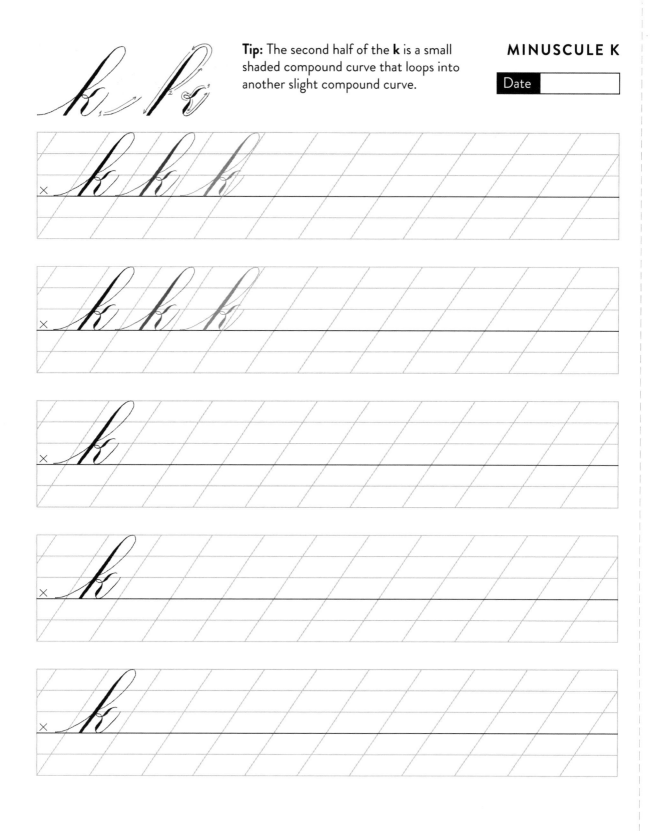

Tip: The second half of the **k** is a small shaded compound curve that loops into another slight compound curve.

Date

COPPERPLATE CALLIGRAPHY PRACTICE BOOK

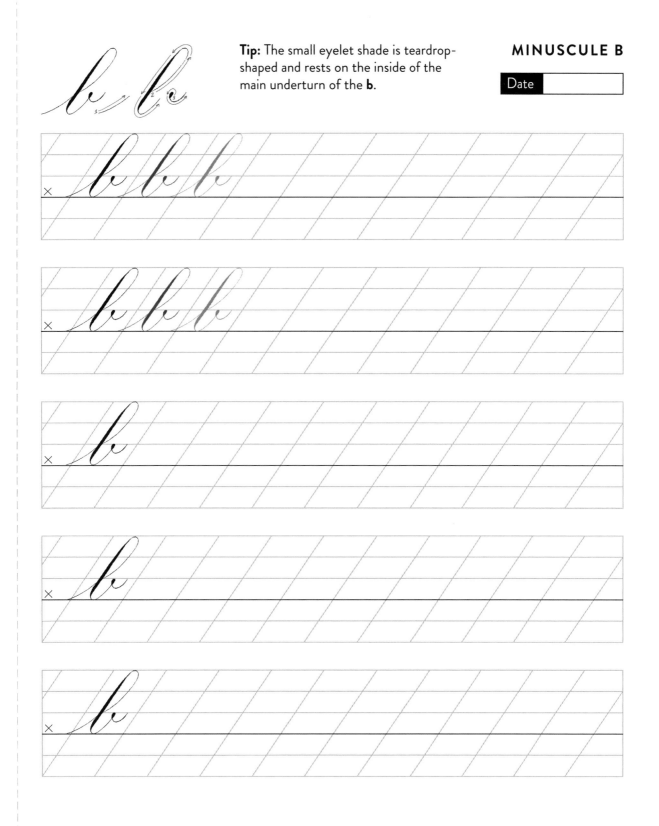

Tip: The small eyelet shade is teardrop-shaped and rests on the inside of the main underturn of the **b**.

Date

Tip: The descender of the **f** reaches the first descender line.

MINUSCULE F

Date

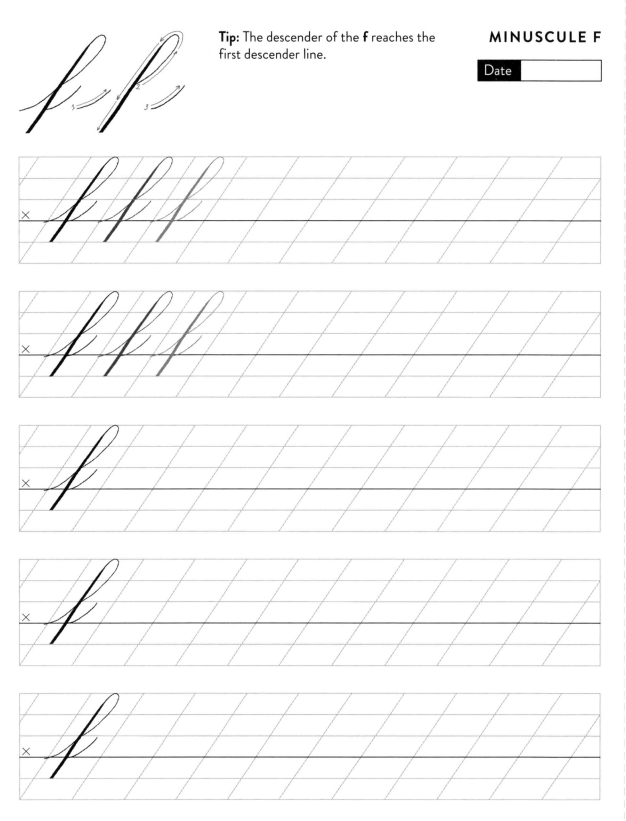

COPPERPLATE CALLIGRAPHY PRACTICE BOOK

MINUSCULE GROUP 4: DESCENDERS

Descenders come in different shapes and sizes. All of these letters dip below the baseline to form a loop, with the exception of the p. Similar to the ascenders, the loops of descenders should be bulbous. The loops of the z and q can be a little more symmetrical than the other loops. The descender of the p ends in a sharp squared bottom. Don't forget to check your slant lines and make sure your letters align with the slant angle.

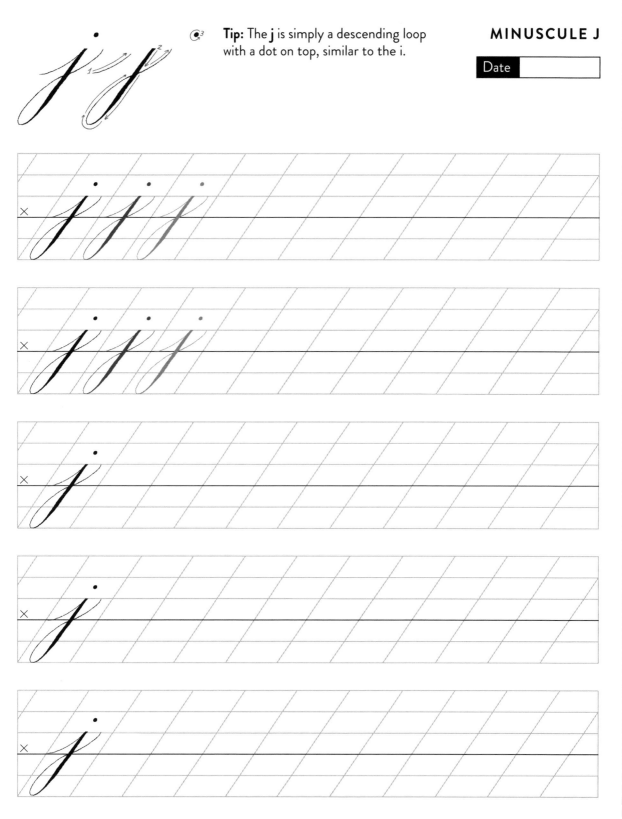

Tip: The **j** is simply a descending loop with a dot on top, similar to the i.

MINUSCULE J

Date

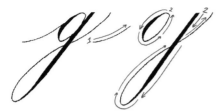

Tip: The bottom curve of the loop on a **g** should mimic the bottom of an oval. The descending stroke just barely touches the oval stroke.

Date

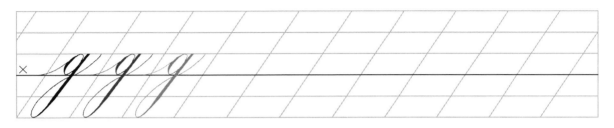

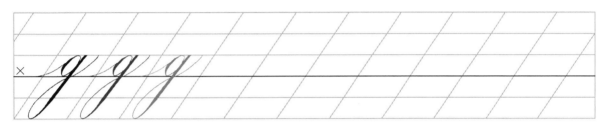

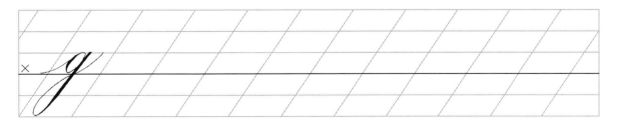

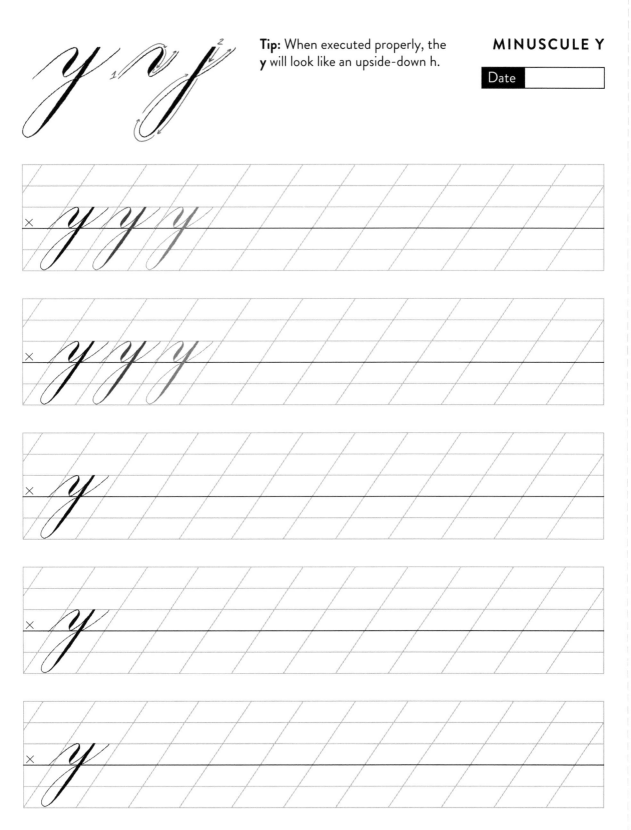

Tip: When executed properly, the **y** will look like an upside-down h.

Date

COPPERPLATE CALLIGRAPHY PRACTICE BOOK

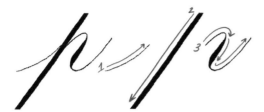

Tip: The shaded stroke of the **p** is a full-strength shade that reaches from the first ascender line to the first descender line. I like to start my stroke a little lower than the first ascender line.

MINUSCULE P

Date

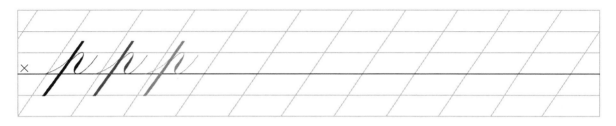

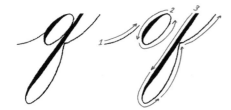

Tip: The descender of the **q** is like a reverse descending loop. Come down with a full shade and move your nib up in hairline to form a loop.

MINUSCULE Q

Date

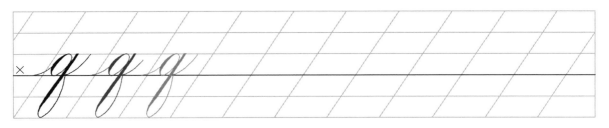

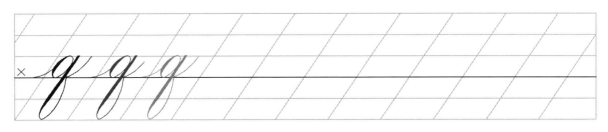

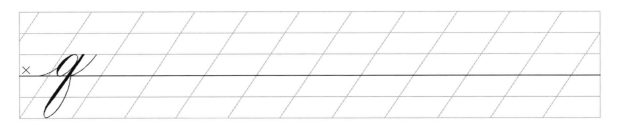

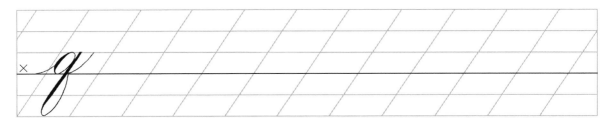

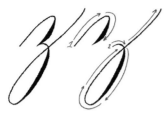

Tip: The first stroke of the **z** is similar to an overturn but curves in just slightly and ends in a point. Dip back up above the baseline before continuing down with the loop of the descender.

Date

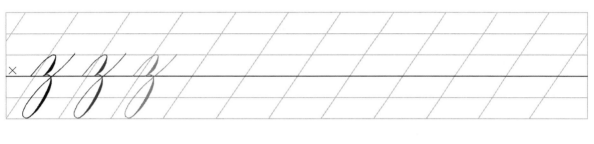

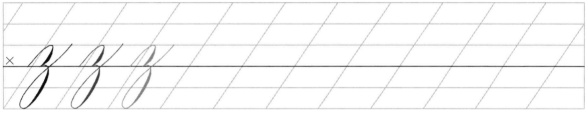

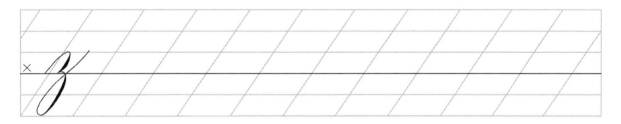

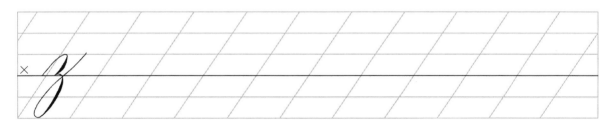

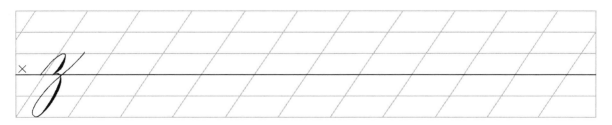

MINUSCULE GROUP 5: COMPOUND CURVES AND EYELETS

The letters in this group are a bit unique in their own way. The v, w, s, and r all have an eyelet, or small shaded mark. The x has a cross bar that moves diagonally across the x-height space. This book includes two ways of writing an r–the traditional way and the more modern/legible way. Pay special attention to the tips on each practice page to learn more about the idiosyncrasies of each letter.

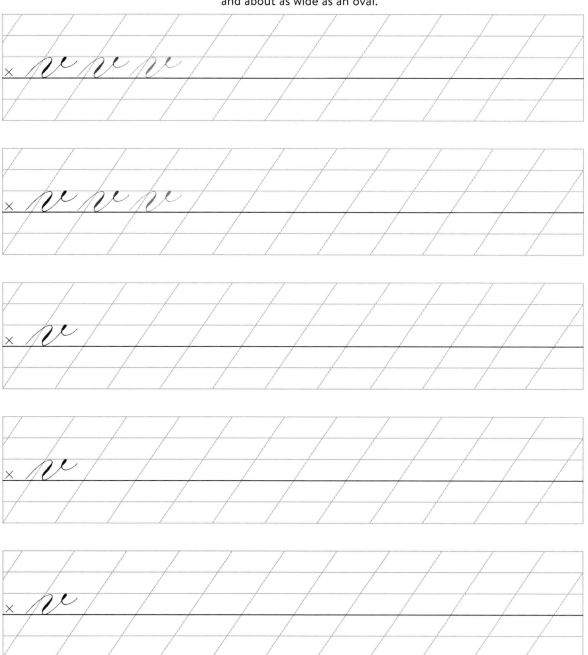

Tip: The small shade of the **v** is rounded at the top and sits on the inside of the compound curve. The small shade exits in a small underturn half an x-height high and about as wide as an oval.

Date

Tip: The **w** is similar to the u, with the addition of a small shaded exit stroke. The small shade exits in a small underturn half an x-height high and about as wide as an oval.

MINUSCULE W

Date

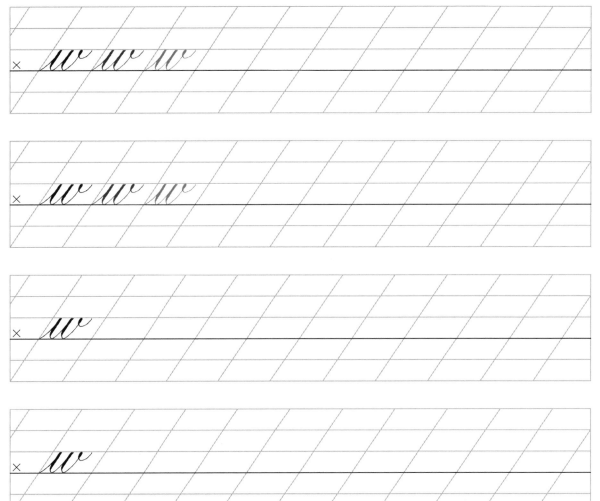

COPPERPLATE CALLIGRAPHY PRACTICE BOOK

Tip: The small shade of the **r** rests above the waistline. The main shaded stroke mimics the shape of the c; it has a slight curve to it.

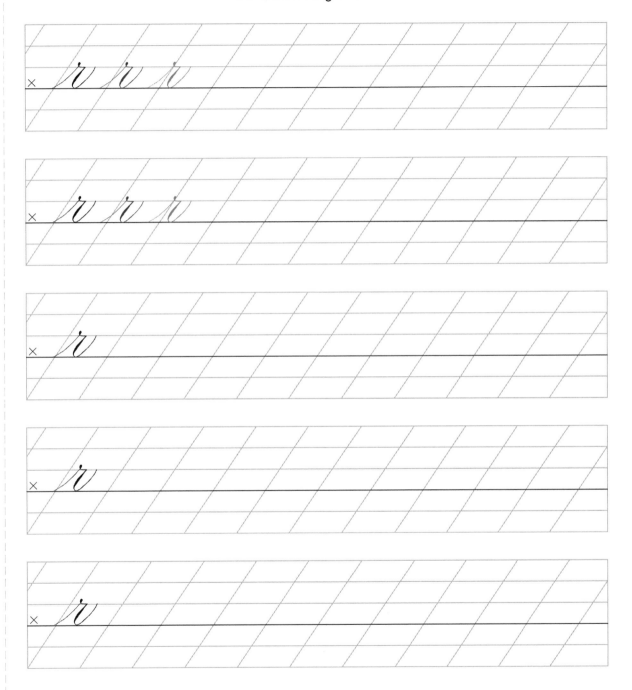

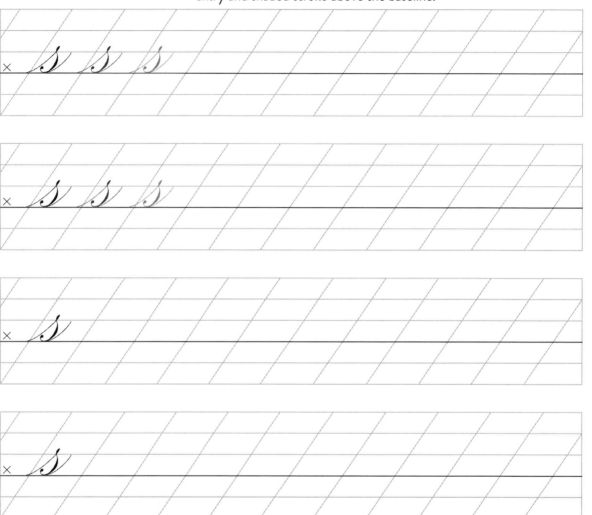

Tip: The small shade of the **s** rests on top of the waistline and aligns with the slant. The main shaded stroke mimics an upside-down c. The small eyelet sits in the middle of the entry and shaded stroke above the baseline.

Date

Tip: The cross bar of the **x** is a gentle compound curve that can be hairline or slightly shaded.

Date

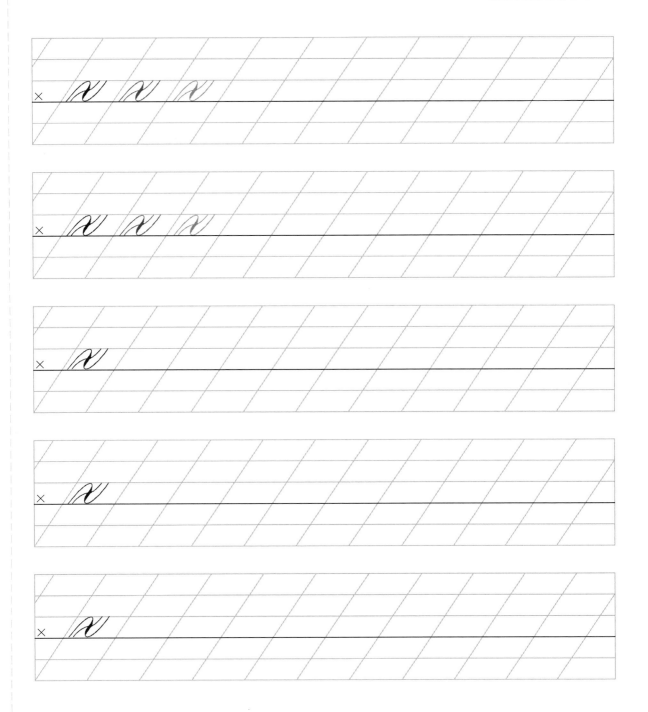

MAJUSCULE BASIC STROKES

Majuscule letters use some of the minuscule basic strokes, but also incorporate beautiful entry strokes and core lines that bring strength and structure to the letter. The capital stem is used throughout many of these letters. It moves elegantly along the slant line and often ends in a small tear-drop or circular shape. This small shade helps to ground the letter; you'll notice it in letters like A and M.

Capital stem

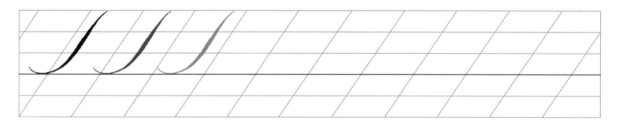

Hairline entry

Compound curve entry

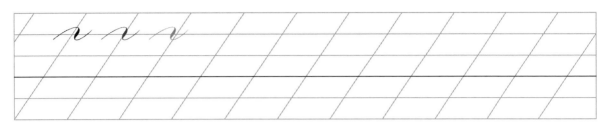

Direct oval entry

Indirect oval entry

Shaded compound curve

MAJUSCULE GROUP 1: CAPITAL STEM

This group uses the capital stem or an interpretation of a capital stem as the main shape of the letter. The J is much more elongated, taking up five full x-height spaces. Make sure to keep these letters on slant. The capital stem should glide along the slant line and enter and exit with soft curves.

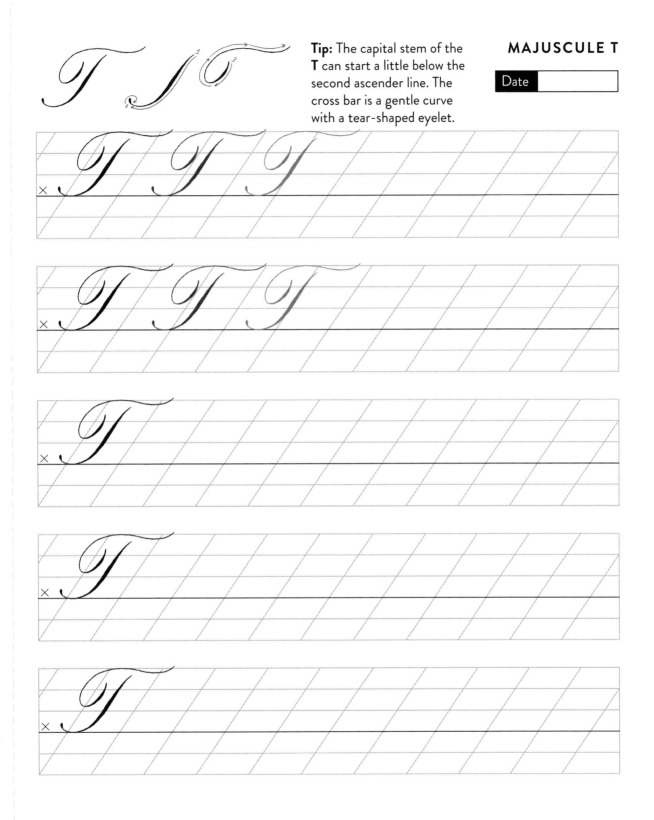

Tip: The capital stem of the **T** can start a little below the second ascender line. The cross bar is a gentle curve with a tear-shaped eyelet.

Date

Tip: The cross bar on the **F** has a small filled loop. The capital stem can start a little below the second ascender line. The cross bar is a gentle curve with an tear-shaped eyelet.

MAJUSCULE F

Date

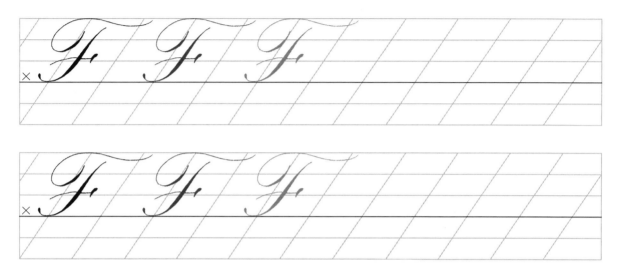

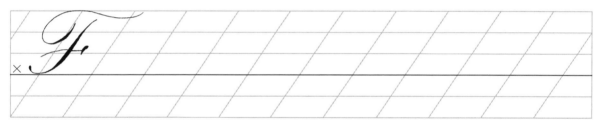

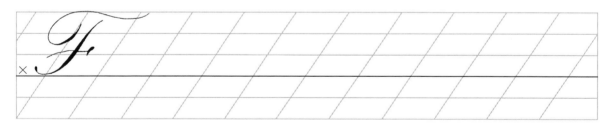

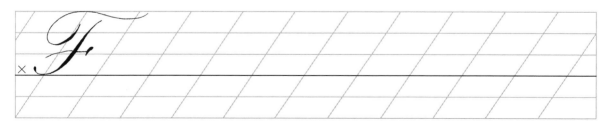

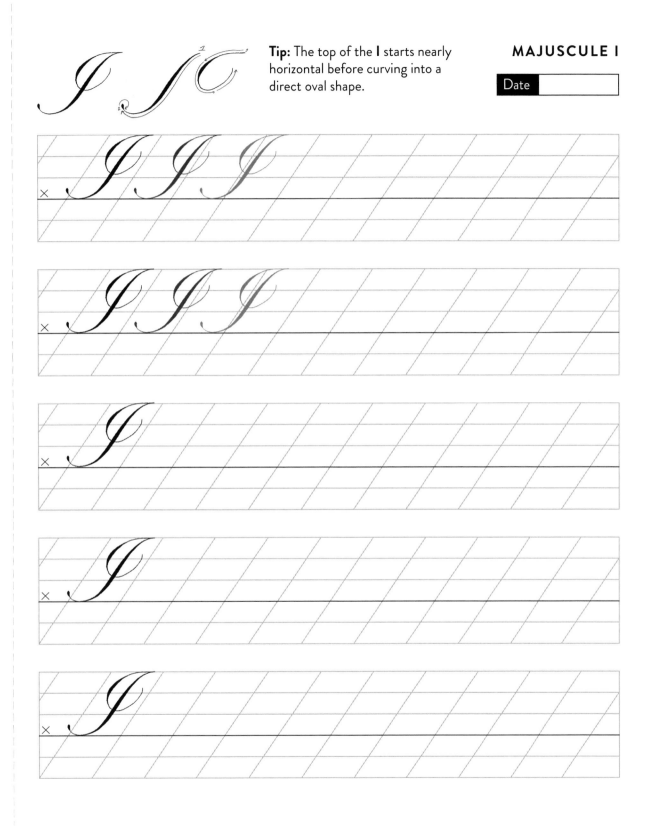

Tip: The top of the **I** starts nearly horizontal before curving into a direct oval shape.

Date

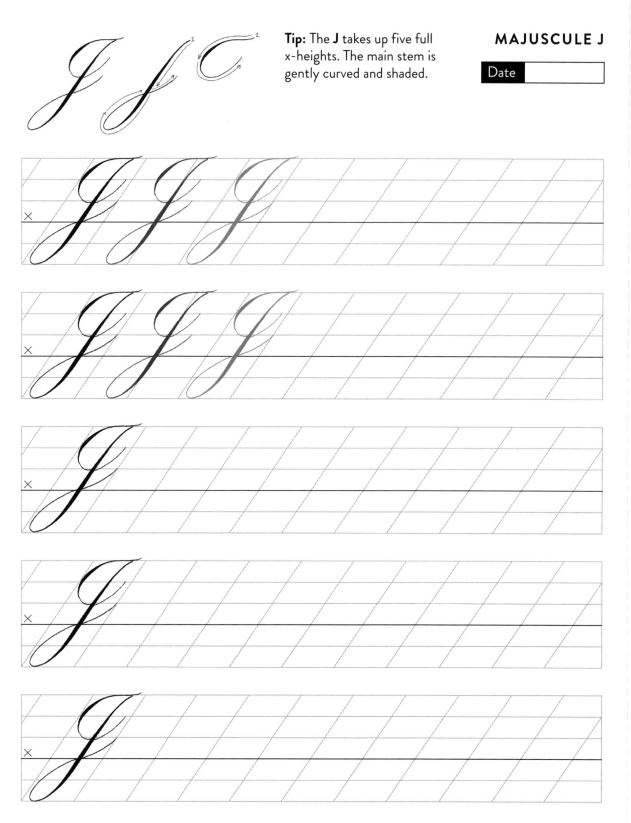

Tip: The **J** takes up five full x-heights. The main stem is gently curved and shaded.

Date

MAJUSCULE GROUP 2: COMPOUND CURVE AND CAPITAL STEMS

This group of letters builds off of the capital stem and uses special entry strokes with compound curve entries and indirect oval entries. As you study, the capital stems on each letter should all be similar, but they will take on a life of their own when you add the additional strokes.

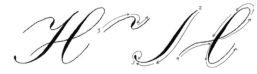

Tip: The first stroke starts a little below the second ascender line. The looped stroke of the **H** is slightly curved and not straight.

Date

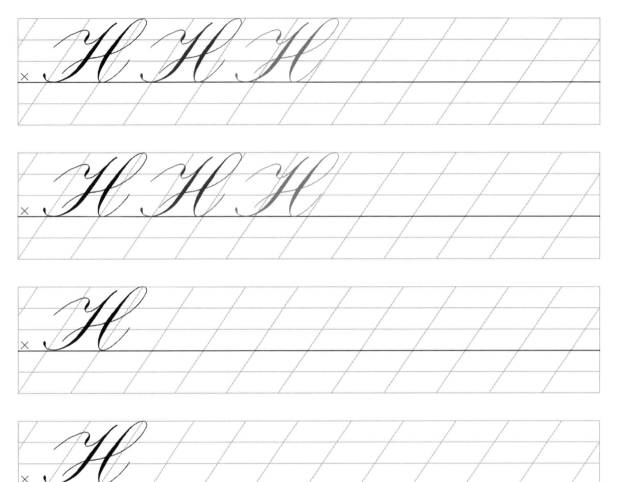

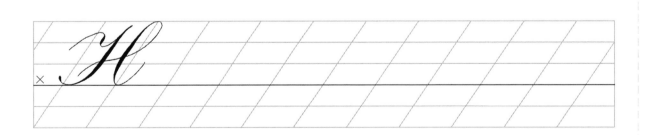

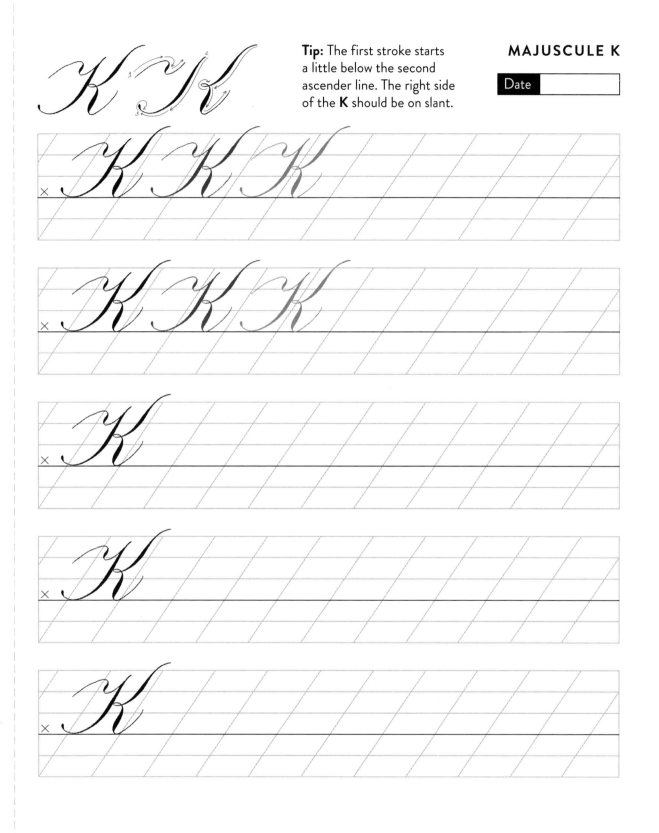

Tip: The first stroke starts a little below the second ascender line. The right side of the **K** should be on slant.

MAJUSCULE K

Date

Tip: The small horizontal loop of the **Z** can point slightly downward. The descender loop is mostly symmetrical.

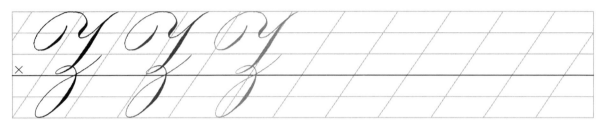

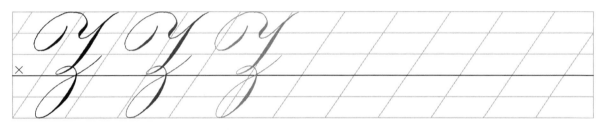

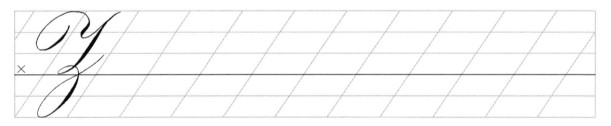

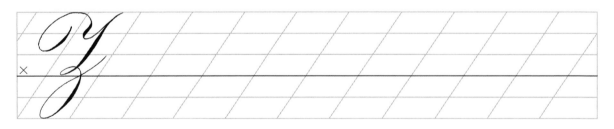

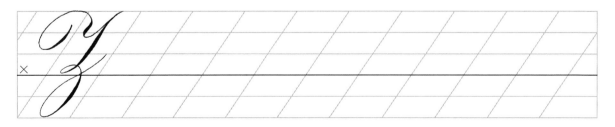

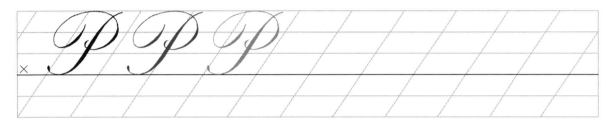

Tip: From entry to exit, the first stroke of the **P** is similar to a horizontal oval. The first stroke should not be flat. There's a tiny shade between the entry stroke and capital stem.

Date

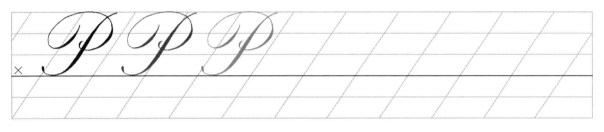

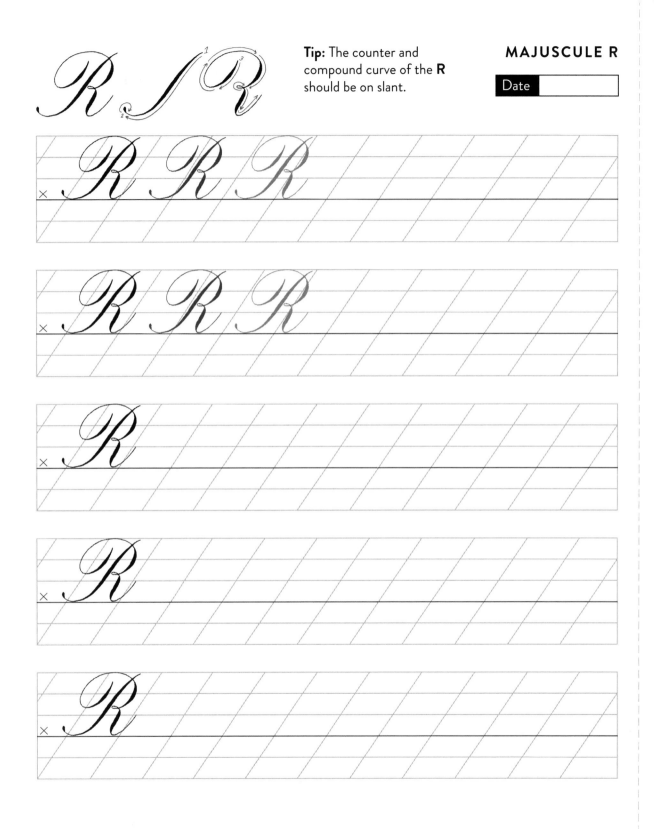

Tip: The counter and compound curve of the **R** should be on slant.

Date

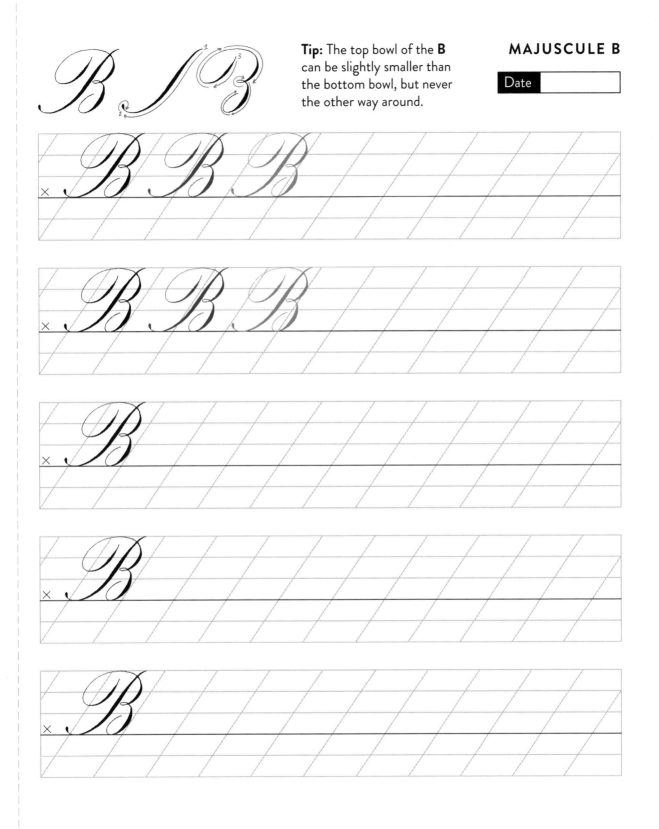

Tip: The top bowl of the **B** can be slightly smaller than the bottom bowl, but never the other way around.

Date

MAJUSCULE GROUP 3: OVAL ENTRY

The entry strokes of this group all have oval shapes (Are you surprised? I told you the alphabet revolves around the oval). Picture the various oval shapes in each letter. We call these "implied ovals." For instance, the C will have an oval entry and the main part of the letter should also resemble an oval. An E will have a few implied ovals, in the entry and the stacked bowls.

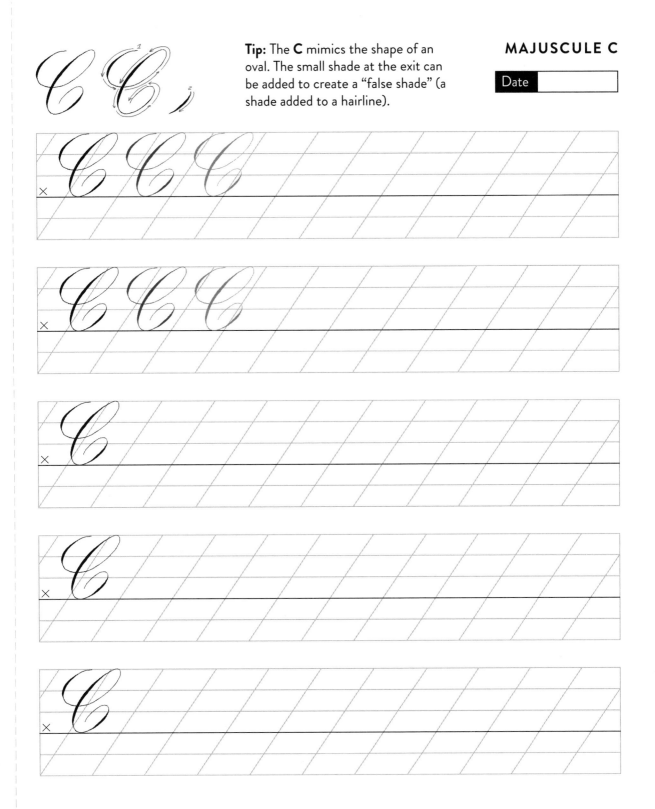

Tip: The **C** mimics the shape of an oval. The small shade at the exit can be added to create a "false shade" (a shade added to a hairline).

Date

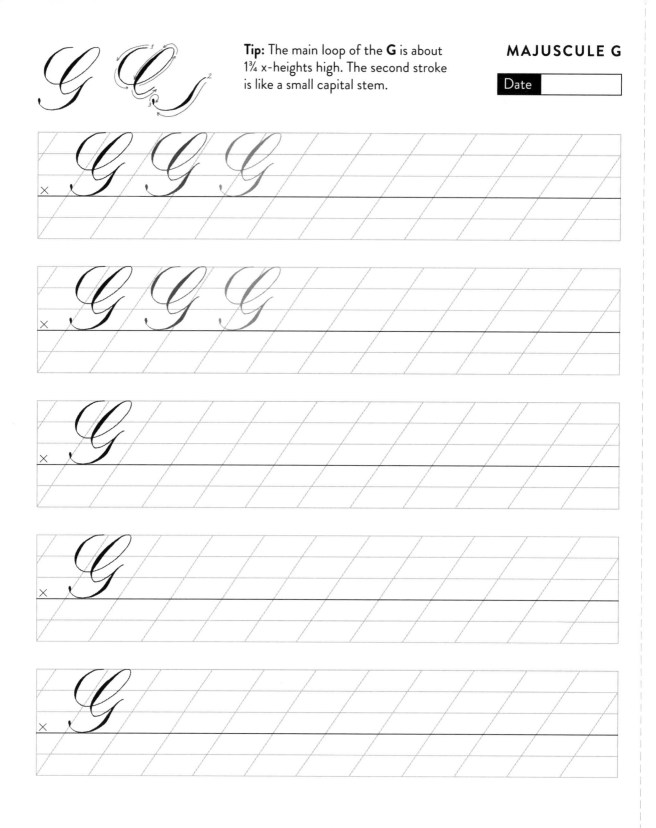

Tip: The main loop of the **G** is about 1¾ x-heights high. The second stroke is like a small capital stem.

Date

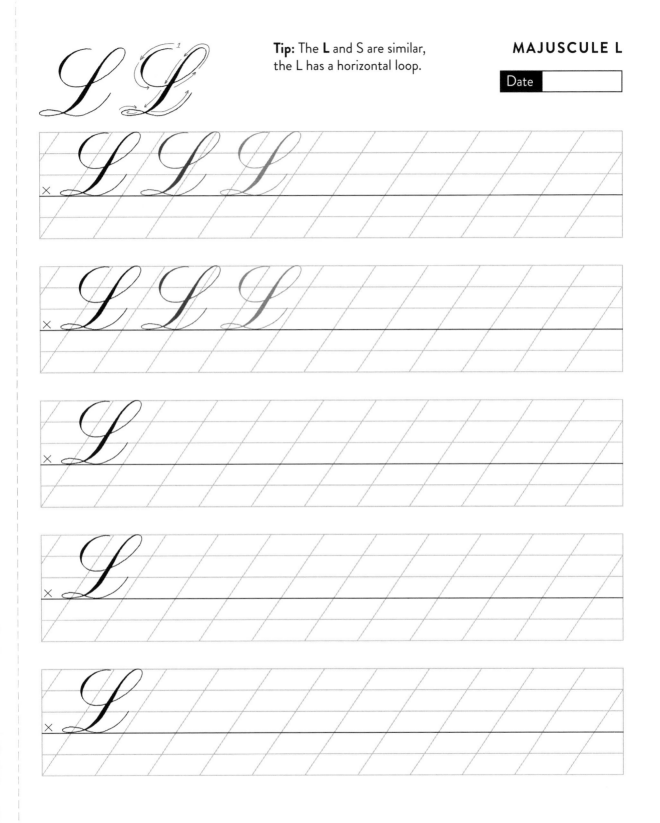

Tip: The **L** and S are similar, the L has a horizontal loop.

Date

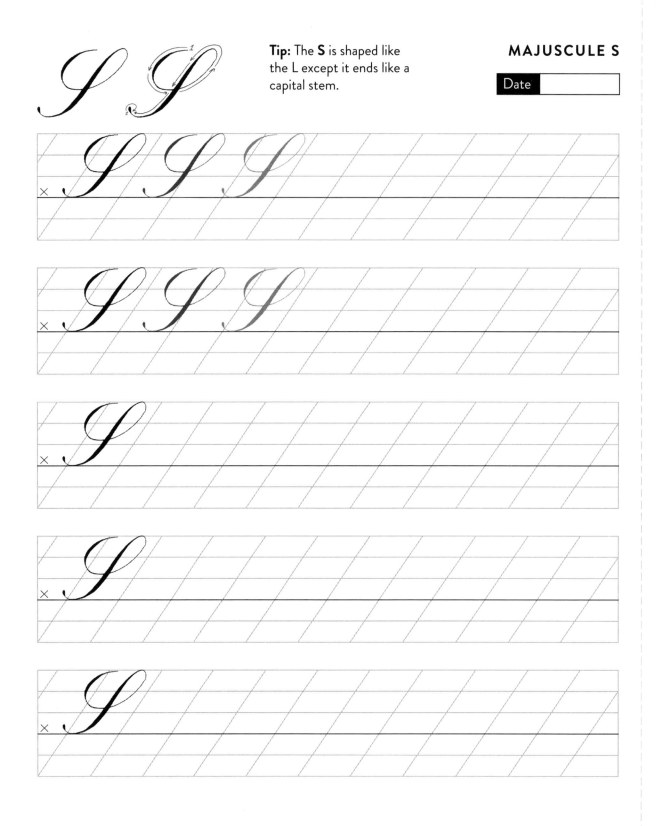

Tip: The **S** is shaped like the L except it ends like a capital stem.

MAJUSCULE S

Date

86
COPPERPLATE CALLIGRAPHY PRACTICE BOOK

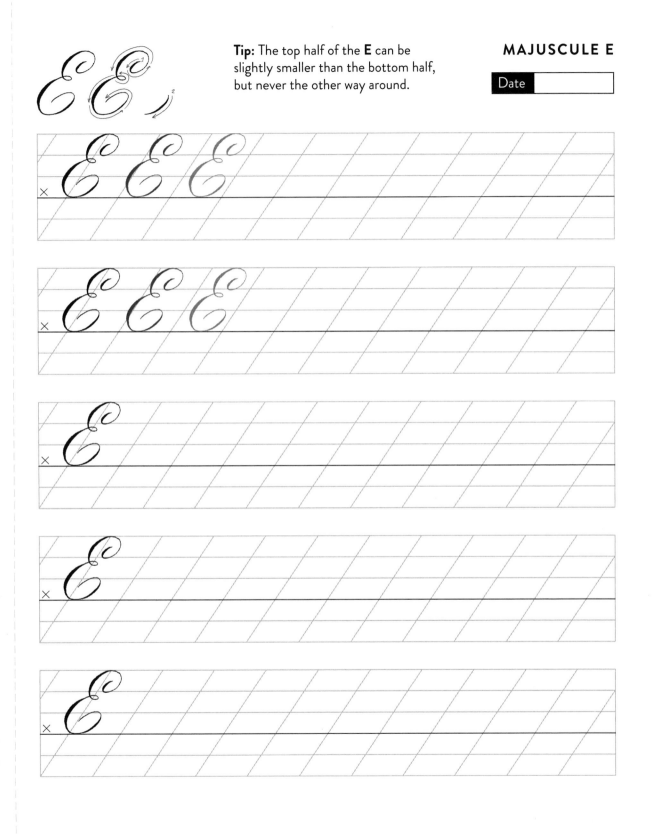

Tip: The top half of the **E** can be slightly smaller than the bottom half, but never the other way around.

Date

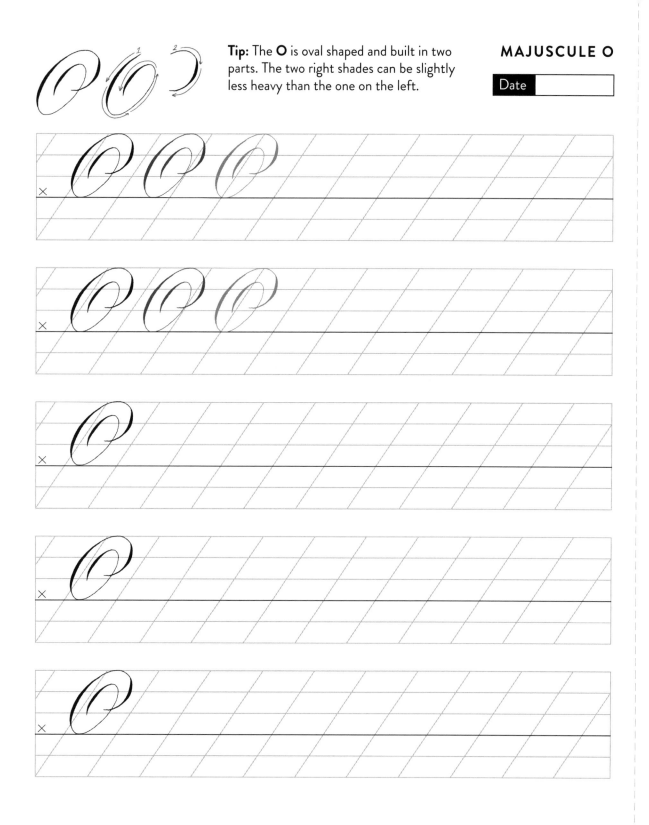

Tip: The **O** is oval shaped and built in two parts. The two right shades can be slightly less heavy than the one on the left.

MAJUSCULE O

Date

MAJUSCULE GROUP 4: INDIRECT OVAL ENTRY

This group uses an indirect oval entry to start the letter. Whether curling around the shape to form a Q or starting with a capital stem to form a D, spacing is key here. The shade of the entry stroke should not be too close to the main shape of the letter. For instance, on the letter U, there should be about the width of an oval between the shade of the entry stroke and the shade of the large compound curve.

Tip: The **Q** is done all in one stroke, with a horizontal loop. The entry stroke and horizontal loop should be aligned so the letter looks balanced.

Date

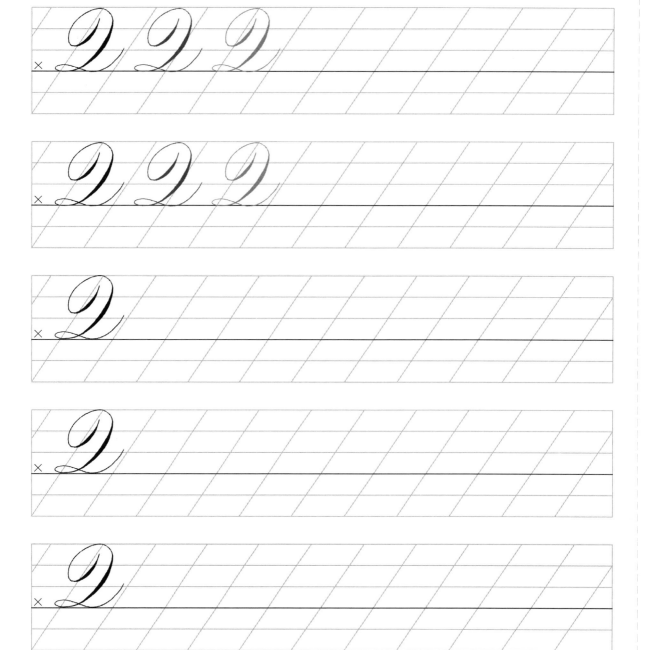

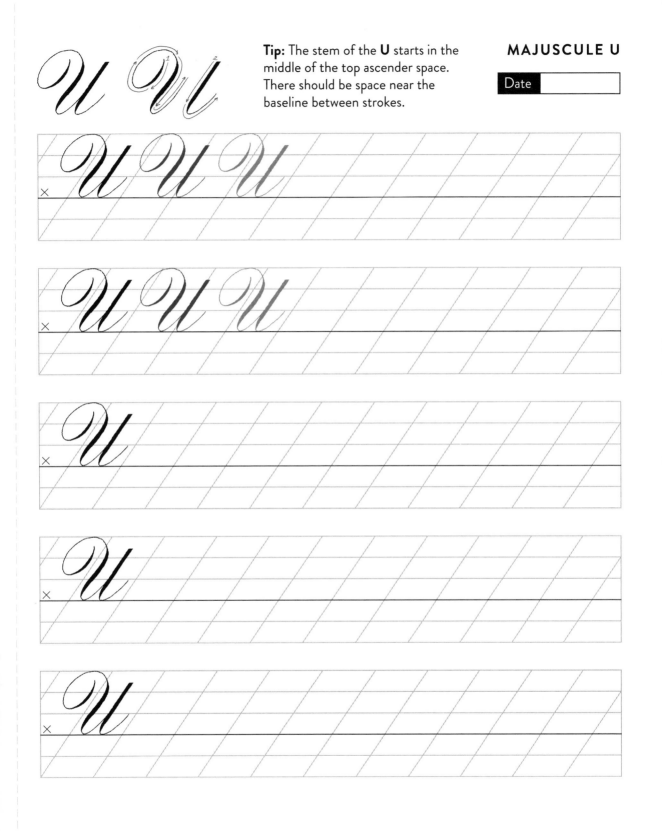

Tip: The stem of the **U** starts in the middle of the top ascender space. There should be space near the baseline between strokes.

Date

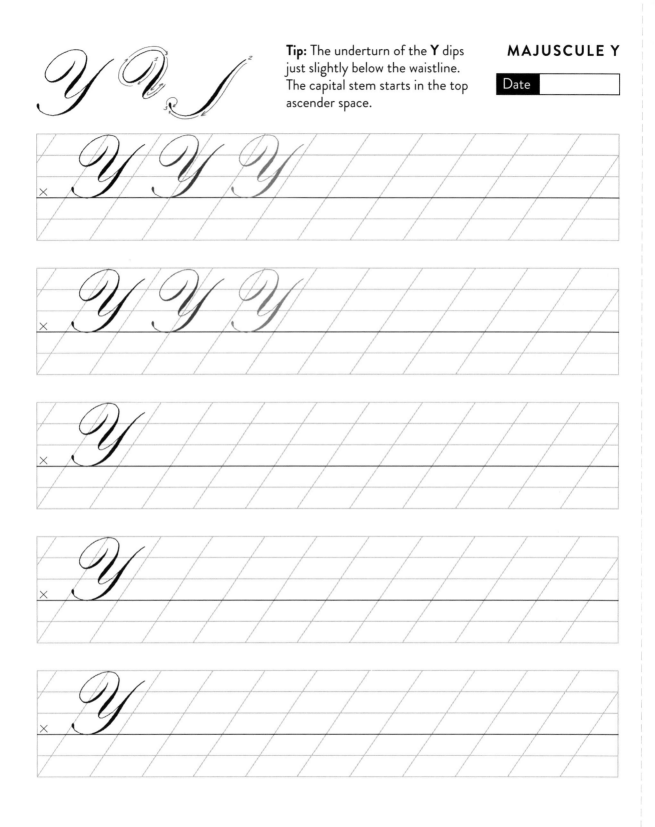

Tip: The underturn of the **Y** dips just slightly below the waistline. The capital stem starts in the top ascender space.

MAJUSCULE Y

Date

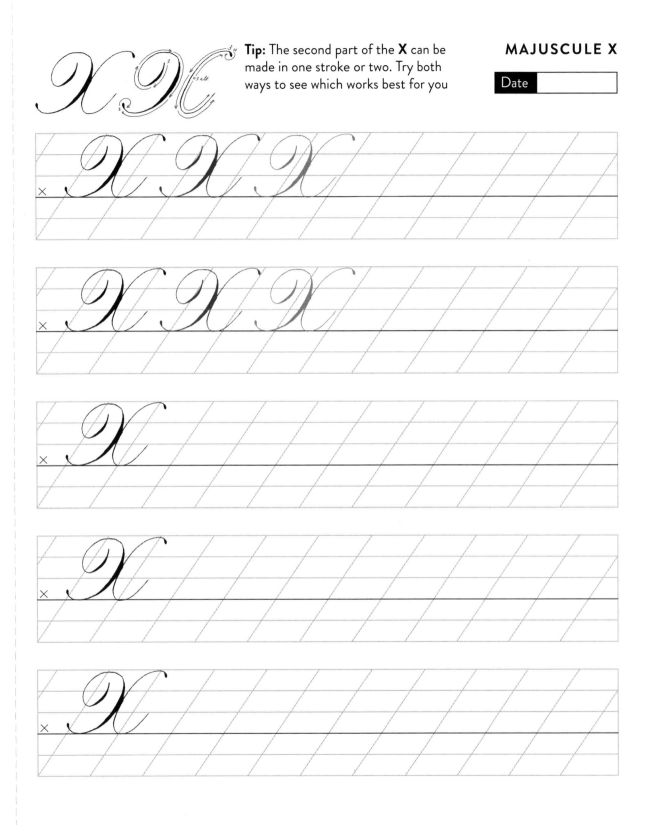

Tip: The second part of the **X** can be made in one stroke or two. Try both ways to see which works best for you

Date

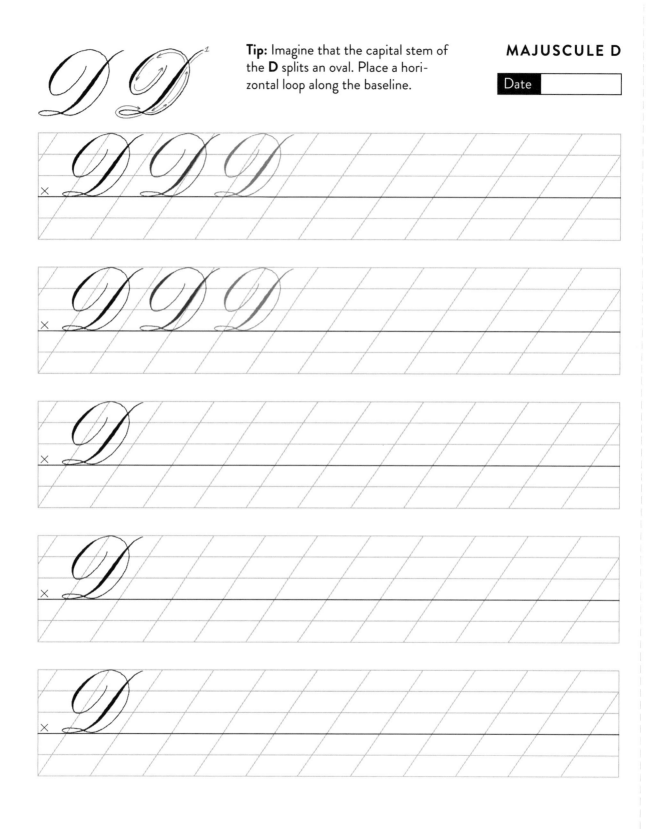

Tip: Imagine that the capital stem of the **D** splits an oval. Place a horizontal loop along the baseline.

Date

MAJUSCULE GROUP 5: HAIRLINE ENTRY AND SHADED COMPOUND CURVE

This group contains some of the more challenging letters, so keep at it–practice makes progress! The entry stroke of the A, M, and N is a subtle compound curve. The bottom portion of the stroke is clearly curved, but it can be deceiving near the 2nd ascender line. Don't come straight upward; curve just the tiniest bit to the right. It's a compound curve, not a concave curve. The biggest tip for learning the W and V is to start and end your shaded strokes in hairline.

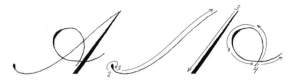

Tip: The entry stroke of the **A** is a hairline with a very subtle compound curve. The main stem is straight.

Date

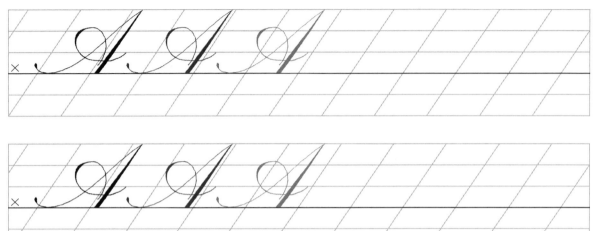

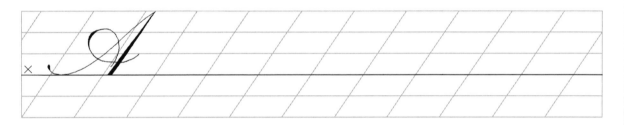

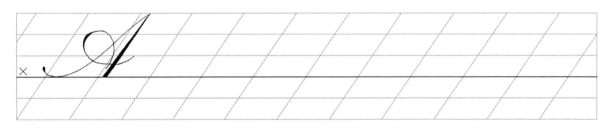

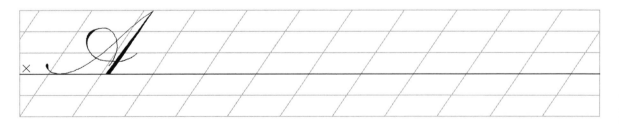

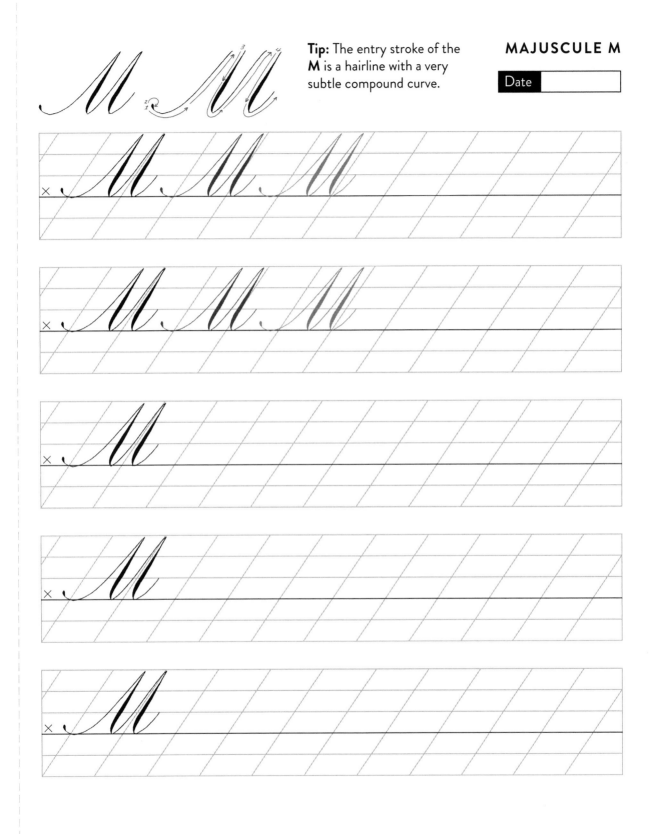

Tip: The entry stroke of the **M** is a hairline with a very subtle compound curve.

Date

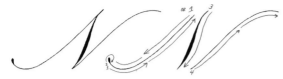

Tip: The entry stroke of the **N** is a hairline with a very subtle compound curve. The main shade is slightly upright and starts and ends in hairline.

Date

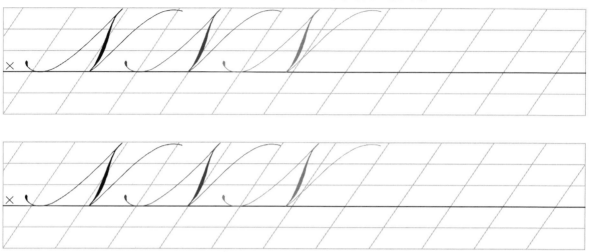

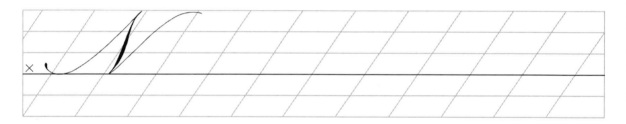

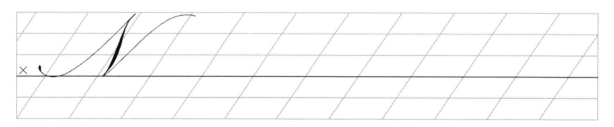

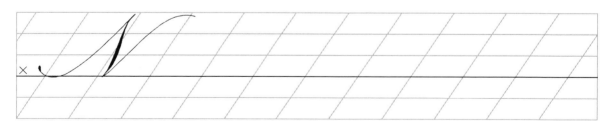

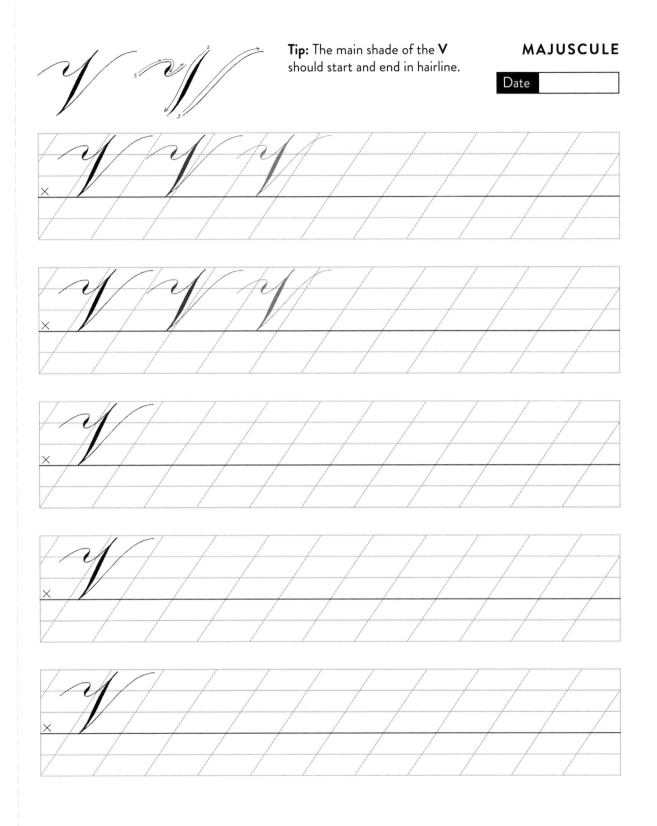

Tip: The main shade of the **V** should start and end in hairline.

Date

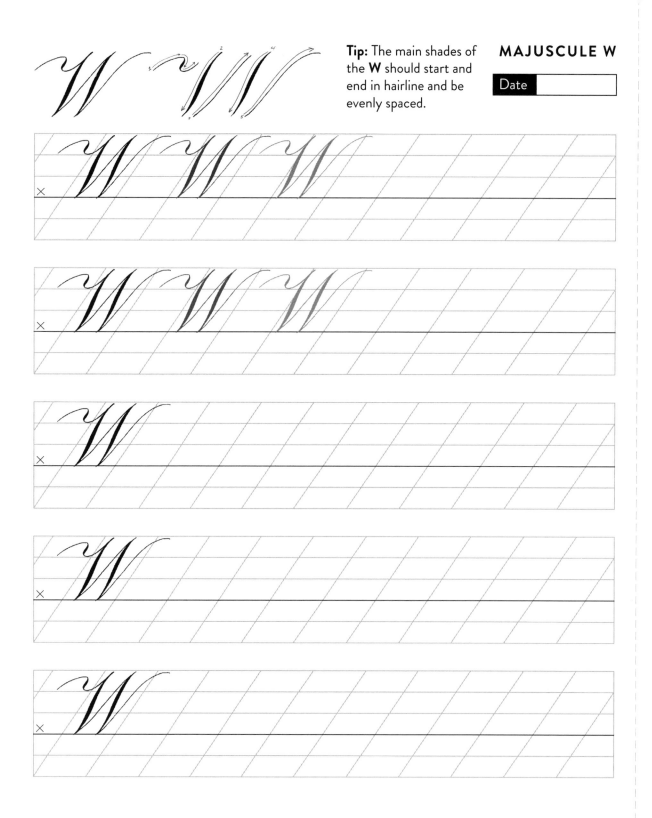

Tip: The main shades of the **W** should start and end in hairline and be evenly spaced.

Date

NUMBERS AND PUNCTUATION

Now that you've learned the letters, take some time to learn the numbers and punctuation. We don't use these symbols and numbers nearly as much as letters, but they certainly come in handy for writing addresses, special dates, and giving a hearty congratulations or friendly greeting. The same basic strokes apply to numbers and punctuation, too. The oval shape is helpful when writing the numbers 6 and 9. Slightly adjust the compound curve shape to be a compressed height but elongated width for numbers 2 and 7. Visualize the implied ovals on the ampersand.

Tip: The stem of the **1** starts in hairline and ends in shade.

NUMBER 1

Date

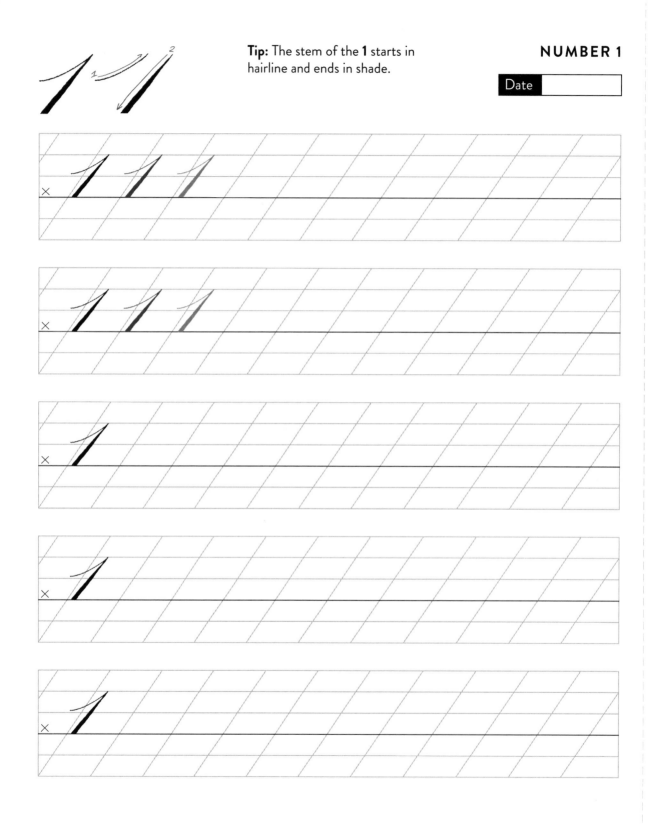

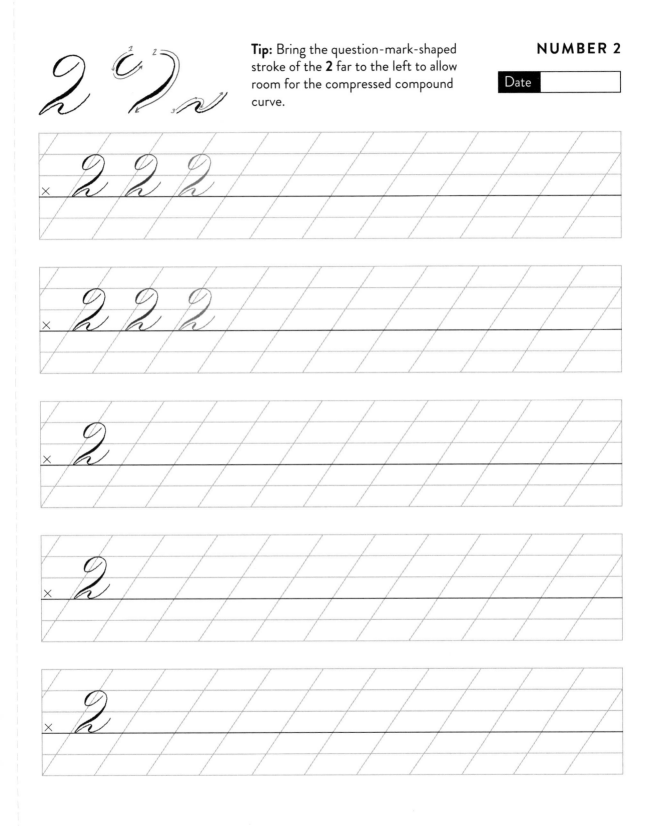

Tip: Bring the question-mark-shaped stroke of the **2** far to the left to allow room for the compressed compound curve.

Date

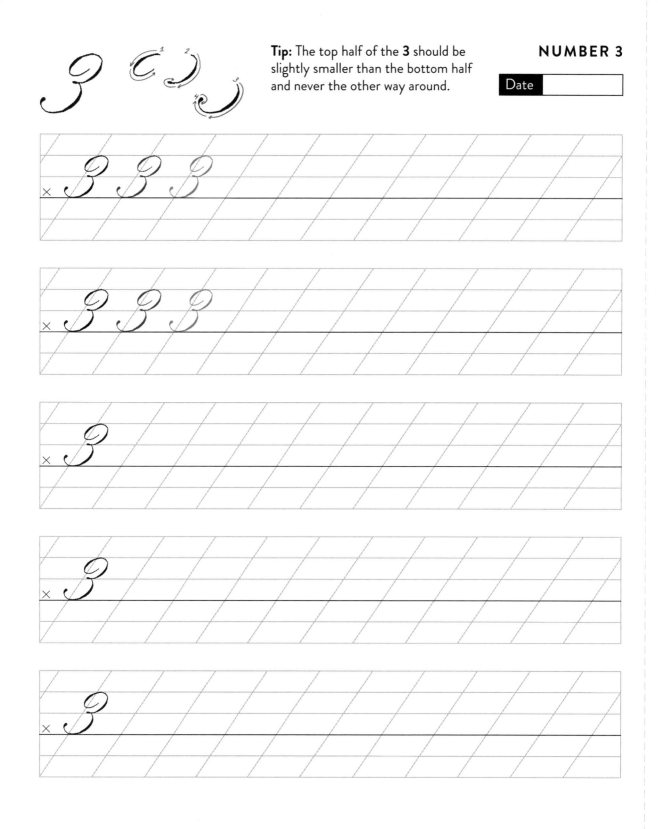

Tip: The top half of the **3** should be slightly smaller than the bottom half and never the other way around.

Date

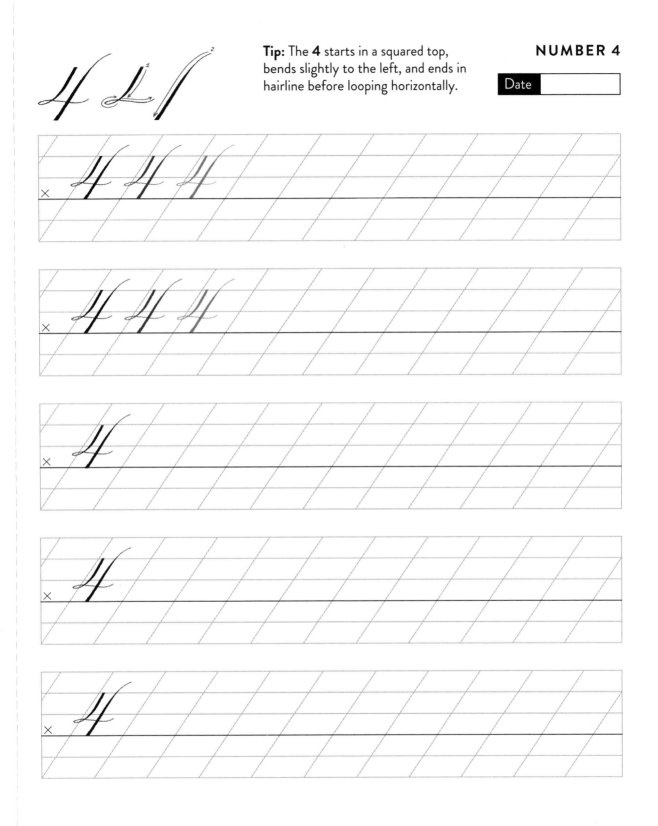

Tip: The **4** starts in a squared top, bends slightly to the left, and ends in hairline before looping horizontally.

Date

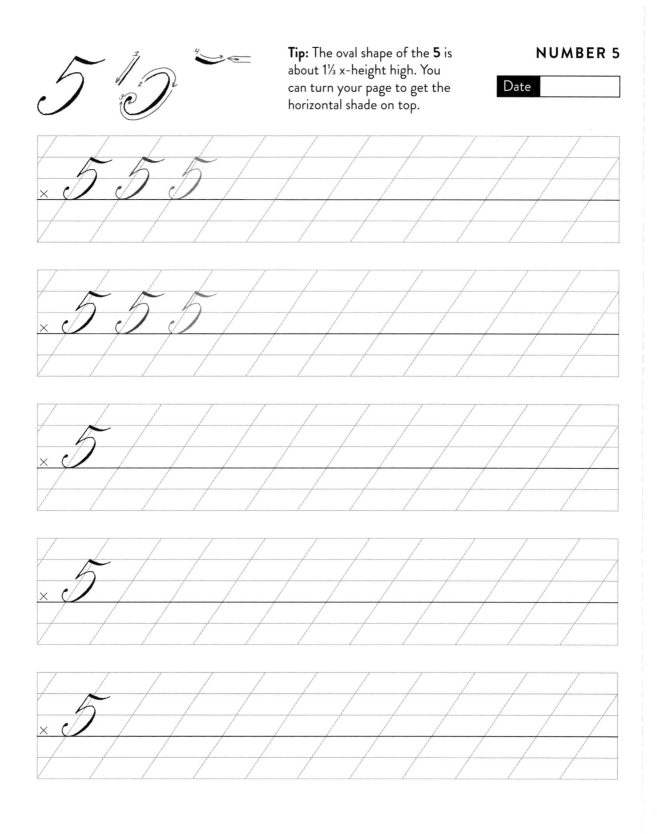

Tip: The oval shape of the **5** is about 1⅓ x-height high. You can turn your page to get the horizontal shade on top.

Date

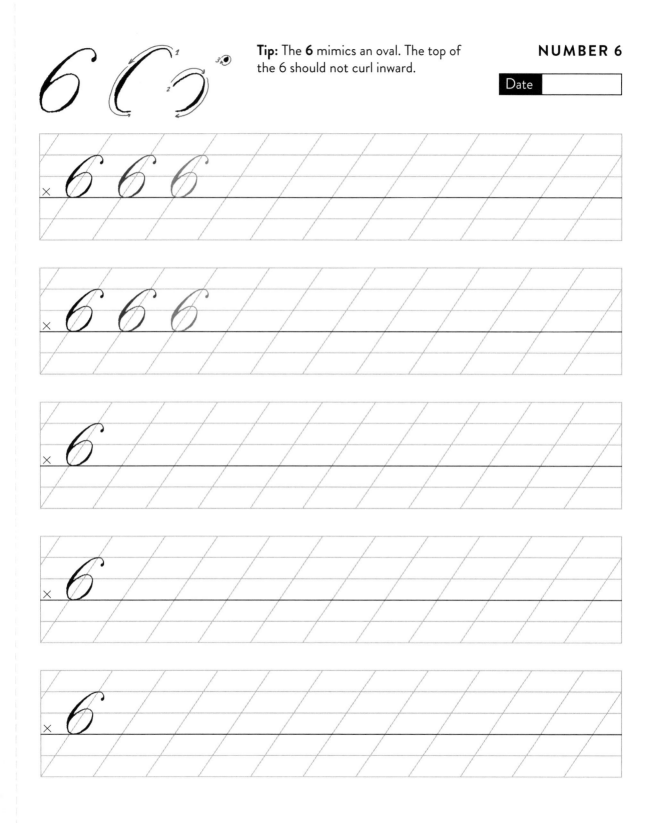

Tip: The **6** mimics an oval. The top of the 6 should not curl inward.

Date

6 6 6

6 6 6

6

6

6

Tip: Create a pressurized tick mark before adding the small compound curve on the **7**. The stem starts in hairline and ends in shade.

Date

Tip: After creating a figure **8**, you can add a false shade on the left side of the number.

Date

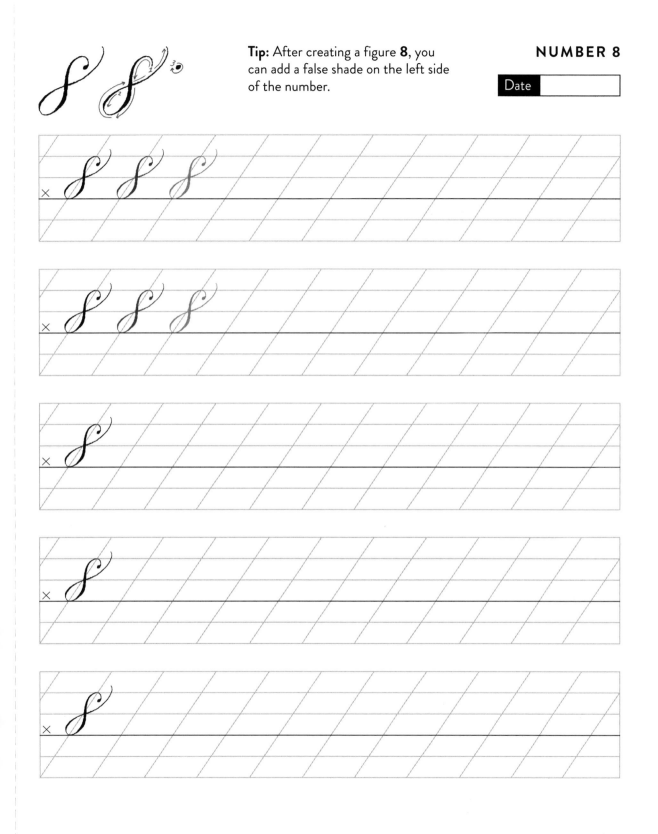

Tip: The **9** is an upside-down 6 and mimics the shape of an oval.

Date

COPPERPLATE CALLIGRAPHY PRACTICE BOOK

Tip: The **0** is an oval with shades on both sides. This shape can also be made in one stroke with one shade on the left.

Date

Tip: The **period** is a full round dot.

Tip: The **comma** is a full round dot that is tapered into a curved hairline.

Tip: The two dots of the **colon** should be on slant.

Tip: Quotes are shaped like commas. The first set is upside down, indicating the start of a sentence.

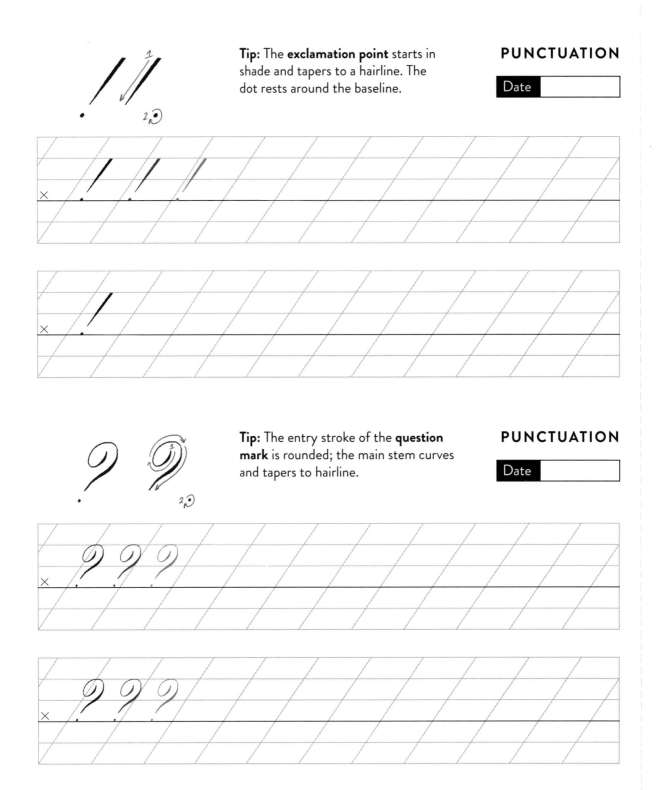

Tip: The **exclamation point** starts in shade and tapers to a hairline. The dot rests around the baseline.

Tip: The entry stroke of the **question mark** is rounded; the main stem curves and tapers to hairline.

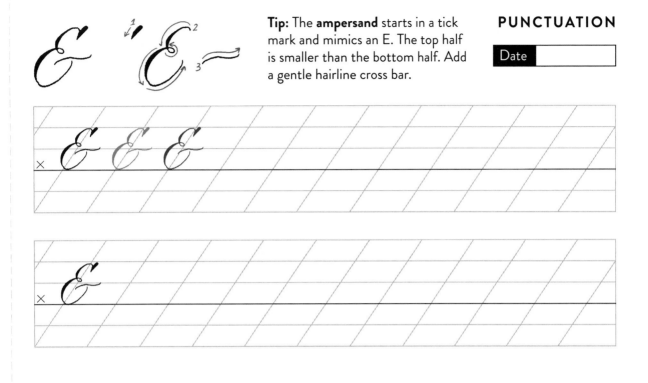

Tip: The **ampersand** starts in a tick mark and mimics an E. The top half is smaller than the bottom half. Add a gentle hairline cross bar.

Date

GLOSSARY

Ascender: A stroke or letter that extends above the waistline.

Baseline: The line on which all letters sit.

Bowl: The curved part of a letter, such as the top and bottom shapes in a capital B.

Capital line: The top guideline that majuscule letters reach. Also called the head line.

Counter: An enclosed or partially enclosed space in a letter, like the center of a letter o, or the space in a letter n.

Cross bar: A horizontal stroke that crosses a letter, such as that in the letter t or capital F.

Descender: A stroke or letter that extends below the baseline.

Downstroke: A stroke that is pulled in a downward motion, usually with pressure added to create a weighted stroke.

Ductus: The order of strokes used to create a letterform. Also known as stroke order.

Entry stroke: A stroke that precedes a letterform. Used at the start of each letter and word.

Eyelet: A small shaded stroke, typically teardrop or oval shaped.

Exit stroke: A stroke that follows the completion of a letterform. Usually connects to another letter.

False shade: A shaded stroke that is added to a hairline stroke, typically on strokes that would have been an upstroke (like adding shade to the capital C).

Finger movement: A movement during which the fingers move the penholder across a small area of the paper to make a stroke. This movement is handy for writing small letters or strokes.

Flourish: A decorative stroke.

Letter slope/slant: Number in degrees of the angle of letters. Example: Copperplate is written at a 55-degree slope.

Minuscule: A lowercase letter.

Majuscule: An uppercase or capital letter.

Slant line: A line used to represent the letter slope.

Upstroke: A stroke that is made in an upward motion to form a hairline.

Waistline: The line to which the body of minuscule letters reach.

Whole-arm movement: A movement when writing during which the fingers do not move but remain firmly grasped on the staff of the penholder. To make a mark, the shoulder and arm muscles are used to move the pen across the paper. This movement is handy for writing larger letters. A whole-arm movement may sometimes transition to finger movement depending on the letter or stroke.

X-height: The height of the body of minuscule letters. Distance between the baseline and waistline.

ACKNOWLEDGMENTS

Thank you to the wonderful team at Ulysses Press. Thanks to Claire for the accountability and months of emails that have gotten us to this point, and to Renee for working with my technical jargon to make calligraphy more accessible and digestible to more people.

I consider Sarah Richardson, author of *Copperplate Calligraphy from A to Z*, to be my first calligraphy friend. We met at a calligraphy conference, and I'm grateful to her for connecting me with Ulysses Press to write this book for all of you.

I wouldn't be half the calligrapher I am today without the people who have generously shared their time, talents, and experiences. Thank you Ajab, Amy, Angie, Ashley, Chantelle, Emily, Marisa, Meagan, Megan, and Rachel. Because of them I know how much to charge, how to write on ribbon, and the proper way to address a judge's name on an envelope.

A special thanks to Amy (you get two thank-yous, my friend!) for imparting her left-handed wisdom and for the many video chats about how to approach this book.

Thank you to Suzanne and Heather, two teachers who have demonstrated a teaching philosophy that has no secrets. They both inspire me to empower others to learn and experience the joy of writing.

I could thank my family, my "Gabagools," for just about everything, but as it relates to the book, I'll say thanks to Mom, Dad, Charlie, and Cat for sharing in my excitement and encouraging me to take this leap. Thank you to my husband William for reminding me of my deadlines ("have you worked on your book this week?"), sitting with me in coffee shops while I wrote, and learning about and embracing my calligraphy world.

Last, I want to thank Betsy, my first calligraphy teacher. I remember watching Betsy write Copperplate in her signature left-handed style–upside down. All my "firsts" in calligraphy—first Copperplate classes, broad edge lessons, and conferences—were because of Betsy's generosity of knowledge. She introduced me to a whole world of creativity I did not know existed. She passed along so much to me, and my hope is that through this book, some of her wisdom is in turn passed on to you.

ABOUT THE AUTHOR

From the moment the tines of her pointed pen nib split, Christen Allocco Turney was hooked on calligraphy and has not looked back. She is a member of the Washington Calligraphers Guild and the International Association of Master Penmen, Engrossers and Teachers of Handwriting. Christen is the cohost of *The Calligraphy Podcast* and teaches students all across the globe. She works in both broad edge and pointed pen calligraphy, but has a particular love for Copperplate and its variations.

Christen is an amateur baker, winter enthusiast, and Jersey girl at heart. She lives in Norfolk, Virginia, with her husband and their sweet pit bull, Niko.